MW00826952

CHINESE-NESS

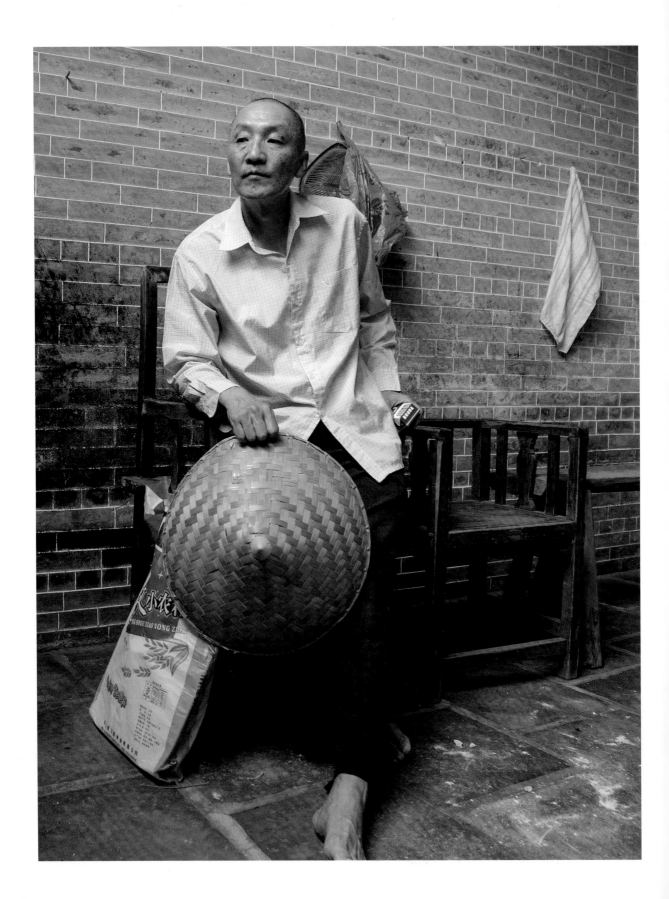

CHINESENESS

WING YOUNG HUIE

The Meanings of Identity and the Nature of Belonging

Wing Young [signature] We are the sum of each other.

MINNESOTA HISTORICAL SOCIETY PRESS

Publication of this book is supported, in part, by a generous gift from the Chinese Heritage Foundation Fund of The Minneapolis Foundation.

Text and images copyright © 2018 by Wing Young Huie. Other materials copyright © 2018 by the Minnesota Historical Society. All rights reserved. No part of this book may be used or reproduced in any manner whatsoever without written permission except in the case of brief quotations embodied in critical articles and reviews. For information, write to the Minnesota Historical Society Press, 345 Kellogg Blvd. W., St. Paul, MN 55102-1906.

www.mnhspress.org

The Minnesota Historical Society Press is a member of the Association of University Presses.

Manufactured in Canada

10 9 8 7 6 5 4 3 2 1

⊗ The paper used in this publication meets the minimum requirements of the American National Standard for Information Sciences—Permanence for Printed Library Materials, ANSI Z39.48-1984.

International Standard Book Number

ISBN: 978-1-68134-042-5 (hardcover)

Library of Congress Cataloging-in-Publication Data available upon request.

CONTENTS

I AM THE YOUNGEST of six and the only one in my family not born in China. Instead, I was conceived and oriented in Duluth, Minnesota. As a Chinese-American, it took me quite a while to realize just how much weight that little hyphen carried. My father owned Joe Huie's Café, a typical chop suey joint, but it was images of pop culture that fed, formed, and confused me. The everyday realities of my family and myself were seldom reflected in that visual landscape, to the point that it caused my own parents to seem foreign and exotic, while I became a stranger and a riddle to myself.

Going to China for the first time in 2010 compounded the confusion. My American-ness made me stick out in my motherland perhaps more than my Chinese-ness made me stick out in Minnesota-land. Seemingly, just my attitude and gait were dead giveaways, even before I opened my mouth to speak my broken Chinese. You can look in the mirror every day and never really see yourself.

So what am I? How does my Chinese-ness collide with my Minnesota-ness and my American-ness? And who gets to define those abstract hyphenated nouns? These were the underlying questions of this project, which is part documentary, part meta-memoir, and part actual memoir, as I collected an array of photographic answers and perspectives throughout Minnesota, in various regions of the United States, and in China. You don't have to be Chinese to experience Chinese-ness.

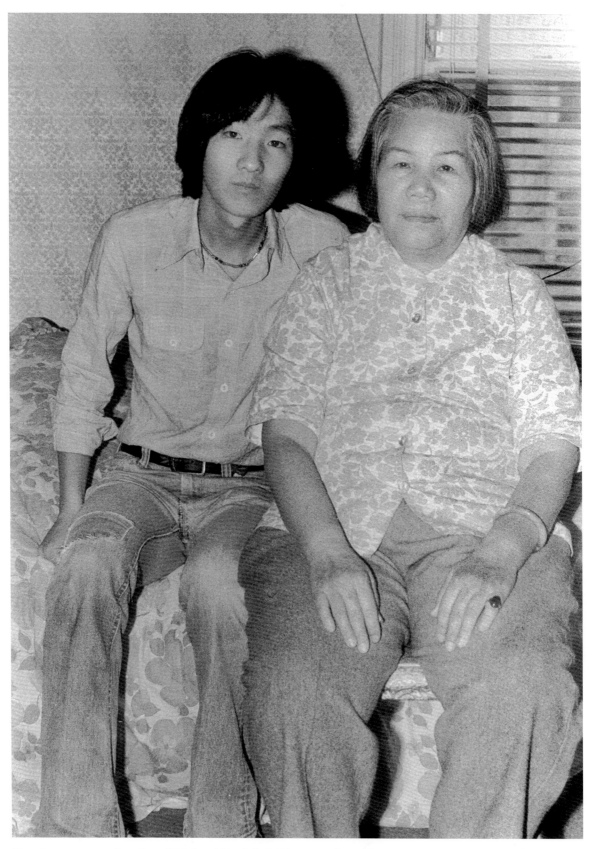

Me and my mom, experimenting with infrared film, Duluth, Minnesota, about 1980

Mom

My parents' lives before my birth were incomprehensible to me. Up until her mid-thirties, Mom raised my sister and four brothers in a tiny farming village—it consisted of seven houses—in the Toisan (Cantonese pronunciation) area of China. Then in 1953, she left her homeland and spent the rest of her eighty-five years on Fifth Street in Duluth, taking care of my next oldest siblings and me while tending to our little brick house and the garden out in back. At night she sat by her bed writing letters to relatives back in China.

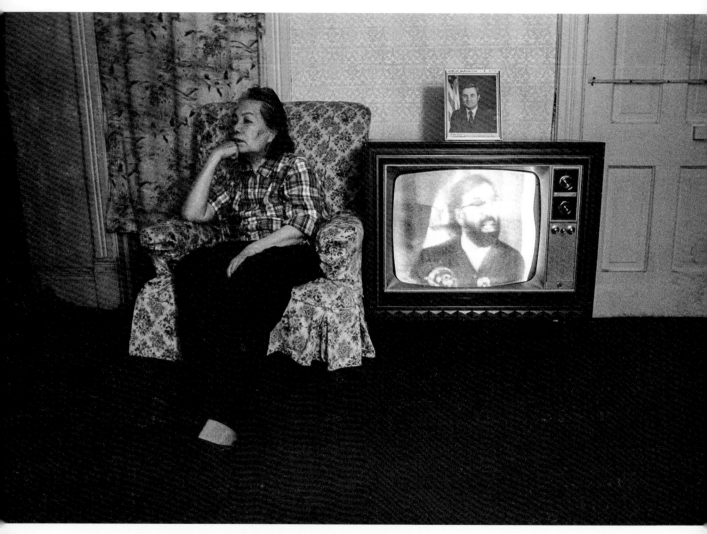

Mom, Francis Ford Coppola at the Oscars, and a photograph of Vice President
Walter Mondale, personally signed to Joe Huie, Duluth, Minnesota, 1975

My mother's tongue

The first words I ever uttered were in Toisan hua, the dialect spoken by my mother. But by the time I started kindergarten, I spoke English like the native I was, and the process of losing my mother's tongue had begun. I have no memory of ever speaking Chinese to my father or my siblings, always English, while the only person I ever spoke to in Chinese was my mother, who never had the opportunity to learn English.

As I got older, the communication with my mom worsened. When I tell people this, most think it strange, but it was my normal. My cultural shame didn't set in until much later.

Mom always sat in this chair, and the TV was usually on. She occasionally watched *The Lawrence Welk Show* on Saturday nights—otherwise it was just noise to her. My mom taught me a lot, but whatever influence she had could not compete with what came out of that box. Popular culture did not reflect the realities of my family, but it was so overwhelming that I became what I saw.

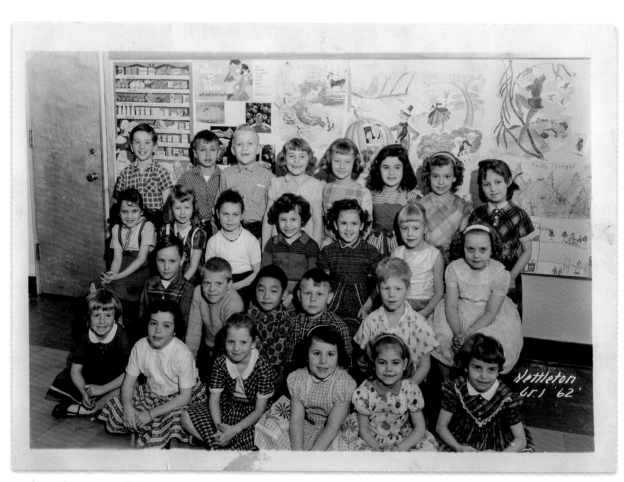

Nettleton Elementary, Duluth, Minnesota

Do I look like I stick out?

This is my first-grade class picture. Do you see me? Throughout much of my public education, I was the only Asian student, not just in my class, but in the entire school. In high school, when another Asian kid showed up, I avoided him. I don't think I realized I was avoiding someone just because he kind of looked like me. It wasn't until well into adulthood and my photographic career that I started to confront my "ethnocentric" filter.

I have come to realize that for most of my adolescence, I thought I was like everyone else. I read the same books, watched the same TV shows and Hollywood movies. But you don't grow up with a mirror in front of you. The people around you are your mirror. You are what you see. I had forgotten what I looked like, and so when I saw this other Asian, I was really seeing myself for the first time. And what I saw made me uncomfortable.

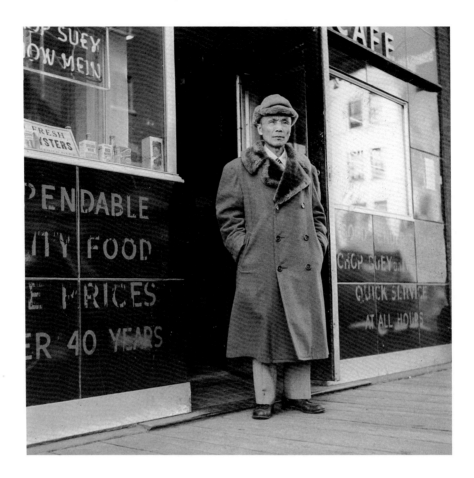

Joe Huie's Café

This photograph of my father, Joe Huie, was taken in the mid-1950s, around the time I was born. He first arrived in Duluth from Guangdong Province in 1909 to work for a relative from the same village, and he would return to China several times over the years to marry my mom and start a family. In 1951, along with my two older brothers, he finally opened Joe Huie's Café (open twenty-four hours a day!). My mom and the rest of my siblings followed a couple of years later.

Before he opened his own place, he worked sixteen hours a day as a dishwasher, cook, and manager, learning English from a nun for one hour after each workday. I started working for my dad when I was twelve. My first job was to keep the books, carefully writing down the restaurant's expenses, in longhand, in a ledger.

I graduated to stints in the kitchen, cashiering, and one memorable summer, as a young teen, waiting on the boisterous bar crowd until the wee hours of the overnight shift. I tearfully complained that none of my friends had to work so much, but I now realize that I had it much easier than two of my older brothers, who had to be there every day (over sixty hours a week!) while attending high school, never once going to a basketball game, dance, or any social event. Dad was still building his business then and didn't want them to go to college, but they went anyway. By the time I was a young adult, my family's hard work afforded me, the youngest, the luxury to become a self-indulgent artist.

The start

I bought my first camera, a Minolta SLR, when I was twenty. A couple of years later I earned my BA in journalism, intending to become a reporter. But after taking a one-week workshop from the iconic street photographer Garry Winogrand, I began to harbor ambitions of becoming an artist. I had never once heard my immigrant parents utter the word *art*. As far as I know, they never set foot in a museum. Their main concern was the family's survival and sending money back to relatives in China. My being an artist was as incomprehensible to them as being a farmer in Toisan was to me.

Fresh out of college, in 1979, I published my first piece: a three-thousand-word article and photo essay on my father for a new magazine in Duluth, *Lake Superior Port Cities*. He had been retired for several years and had shuttered the café because none of us kids had wanted to take it over. In my hometown my father was famous, but I barely knew him.

Growing up, I observed him briefly in the mornings sipping his coffee and at night nursing a shot of whiskey, lost in his thoughts. He was at the restaurant 8:00 AM to 8:00 PM, every single day of the year.

I don't really remember my father speaking directly to me until I started working for him, and even then the conversation was work-related. His meticulous instructions on how to cut the pies was as memorable as any fatherly advice he gave. And so with the start of my career, I decided to give myself permission to ask Joe Huie questions I had never dared to raise—to ask not as a son, but as a reporter.

I have since photographed thousands of strangers, and photographing my father was not all that different. Scrutinizing him through the camera lens and finding out things I had never known was probably the most intimate experience I ever had with him.

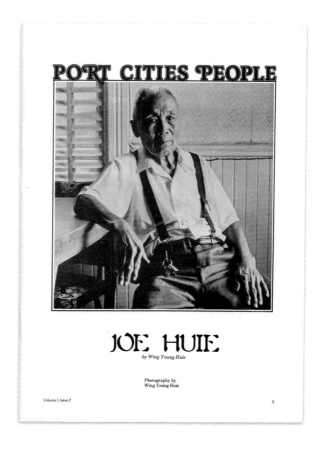

PORT CITIES PEOPLE

JOE HUIE
by Wing Young Huie

Photography by
Wing Young Huie

Volume I, Issue 2

9

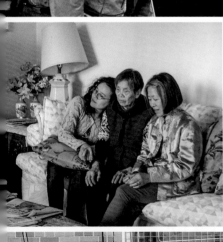
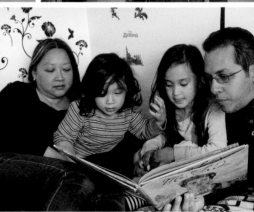
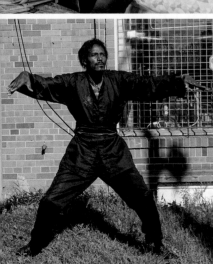
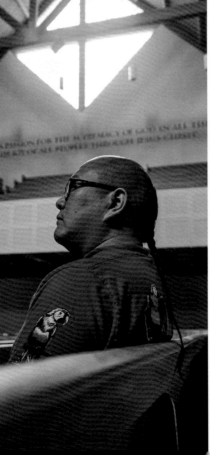
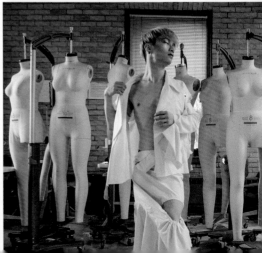

THE MEANINGS OF IDENTITY

—

THE NATURE OF BELONGING

Is Chinese identity personal, cultural, national, political, imposed? Does it migrate, become malleable or transmuted? What is authentic, exotic, kitsch, appropriation, appreciation?

Rather than being about Chinese culture or racial politics per se, this book is about the stuff that falls into the cracks or resides in the back of the mind. Humor and irony are threads, as well as cultural guilt and cultural uncertainty.

However you think about Chinese-ness specifically and identity in general, my goal is that you will find something here that will embolden what you think you know and challenge it, no matter your cultural background.

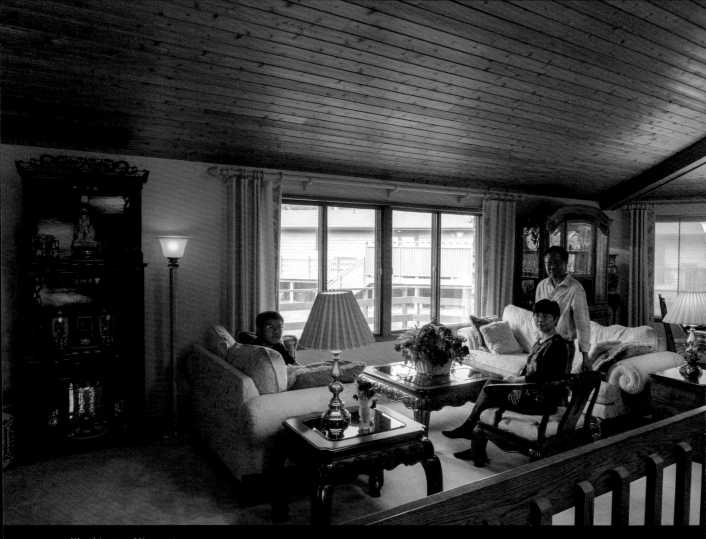

Worthington, Minnesota

Panda House

David and Mabel have worked thirteen-hour days, six days a week, at Panda House, the Chinese restaurant they own in Worthington, Minnesota, so they can enjoy the comforts of their meticulously decorated lakeside home with a private dock. Except it's been months since they've actually sat in the living room pictured here. Or untied the canoe from the dock. Or visited the playroom in the basement with the pool table.

They are too busy working.

Nearly thirty years ago, David spent several weeks driving through Montana, Wyoming, the Dakotas, Wisconsin, Michigan, and Minnesota, searching for a town of around ten thousand people that was Chinese restaurant–less. His quest ended in Worthington, on the southwest edge of Minnesota, now one of the most culturally diverse areas in the state. He's done well, and business is better than ever. One customer flies in from St. Cloud, about 175 miles away, just for takeout. David and Mabel have never met this person, though, because they are always in the kitchen cooking. Not even one minute to talk, they say. Too busy working.

This was David's second dream. His first, as he completed two years of college in Hong Kong in his twenties, was to become an interior designer. But after coming to America to join his parents and siblings, he had to change his dream. With poor English skills and no money to continue college, like many before him, he ended up working in Chinese restaurants.

His brief education, though, fueled his desire for independence and personal success, which he channeled into Panda House. Over the years he has renovated the restaurant several times, merging his first dream with his second. There is, however, little in the décor or design that is indicative of anything Chinese. "I like American style better," he says.

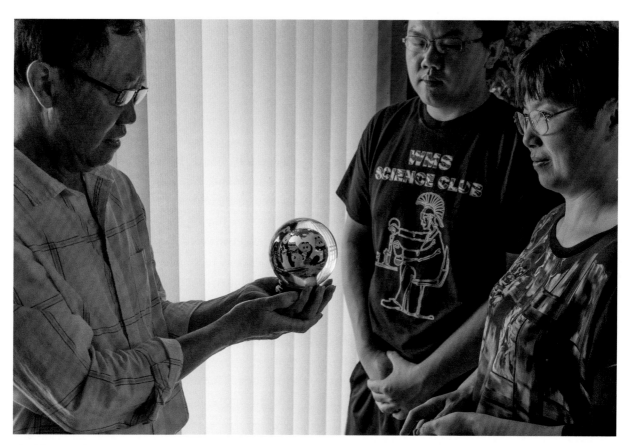

Worthington, Minnesota

IN A TINY DINING ROOM adjacent to the fancy living room, the family gathers every Sunday night for dinner, often their only time in the house together. Embedded in one wall is a large television festooned with various Chinese ornaments, including this crystal ball with a hand-painted image of panda bears, revered symbols of good fortune in China. *Panda* is also one of the most popular names for Chinese restaurants in America, ahead of *Dragon*.

Tears of happiness

David's son Chris, who is entering the tenth grade, was born and raised in Worthington. Although he may be the only Chinese student in his school, his various friends reflect the area's diversity—more than half of the students are people of color. Chris works only weekends at the restaurant, and his interests include clarinet, violin, choir, robotics, football, shot put, discus, and gaming.

Chris is fluent in Cantonese (picked up by listening to his parents), and he speaks to his parents mostly in Chinese. Sitting in a booth at an empty Panda House with Chris and David on a Sunday, their day off, I asked David what he thinks about being Chinese. He gave me a confused look and turned to Chris for explanation in Chinese. David then nodded and spoke about his hard work, his sacrifice, and his customers' loyalty, and he became emotional, wiping away tears with his fingers. Chris started crying, too.

I asked David if talking about this made him sad. "Tears of happiness," he replied. I then asked Chris what he thinks about being Chinese. "I never think about it," he said. "Never." To the father, part of being Chinese is working hard. But for the son, whose future is not yet clear, the only thing he is sure of is that he will never own a Chinese restaurant and work as hard as his dad.

A life I could've had

Most everyone in my family has owned a Chinese restaurant at one time or another, and I've done just about every kind of job it entails: bookkeeper, busboy, dishwasher, cook, and waiter. For nine years I bartended at a Japanese restaurant while struggling as a freelance journalist and photographer in the Twin Cities. My mom, dubious of my ability to make a living (and for good reason), once offered to buy me a hot dog stand if I moved back to Duluth.

At times I've fantasized about opening up my own place, but I'm thinking about holding court and entertaining friends rather than the backbreaking reality. Which is partly why I opened my Third Place Gallery seven years ago as a communal artistic gathering space. I've had more than seventy events there, including one where I cooked a several-course Chinese meal for thirty people—the main dish was lotus root and black mushrooms—stir-frying it all upstairs, in the kitchen of my one-bedroom apartment.

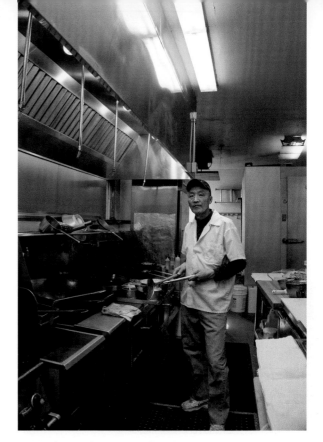

Huie's Chow Mein, Minneapolis, Minnesota

LESS THAN TWO MILES from my gallery is Huie's Chow Mein, a corner chop suey eatery not unlike my dad's, where I have been eating for years. I always wondered if the owner and I were related, and it wasn't until I started this project that I finally talked to him. (He was always in the kitchen.) His last name is Wong. As it turned out, he bought the place in 2005 from a Huie who had bought it from another Huie from Toisan who originally opened the restaurant in 1960.

To visualize the life I could have had, I asked Mr. Wong, who is a hobbyist photographer, if he would photograph me wearing his clothes. I look very much at home, I think. This definitely could have been my career if the photography thing had never panned out. Or running a hot dog stand.

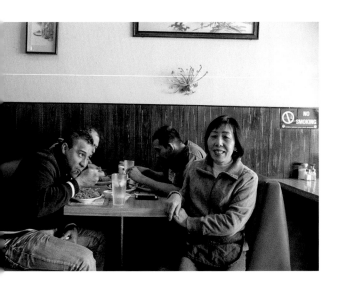
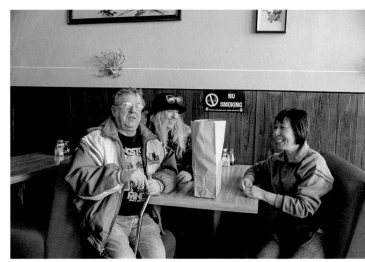
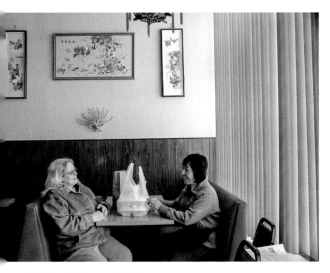
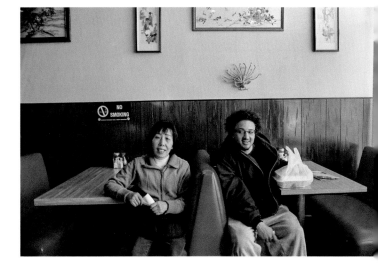

Mei Inn, Minneapolis, Minnesota

Chop suey community

(*Previous page*) I've eaten in a lot of Chinese restaurants, and I am particularly drawn to "authentic" ones like Joe Huie's Café. By that I don't mean the places that serve the actual cuisine from China (which I also love), but rather the classic Chinese-American storefronts that specialize in such American-as-apple-pie standards as egg foo young covered in gravy and gooey celery-based chow mein piled on crunchy noodles—comfort food for me. And for a lot of other people as well: Chinese-American restaurants are, in a sense, community centers, in that they bring together people from various backgrounds who would not be in the same room if not for their shared passion for egg rolls and fried rice.

Rui (in all four photos) and her husband, Shao (usually in the kitchen), both from Guangzhou, opened Mei Inn in south Minneapolis fifteen years ago, taking over a Chinese restaurant space from its retiring owner. John and Kandi (upper right) come here once a week because Rui and Shao make Chinese food "the way it was done in the sixties. They put it in a bowl and tip it upside down on a plate. No one does it that way anymore." James (lower right), who grew up three blocks away, has come here twice a week since 2005, when he was fifteen. "All the other places taste the same. Here it's different." Joel (upper left, with the fork in his mouth) is from Mexico and got a taste for Chinese food when he worked at a Chinese buffet in Texas. Peggy (lower left) and her husband have tried other Chinese restaurants but always come back to this one. "We came here for Valentine's Day. I didn't want to go to a steak house. I wanted Chinese!"

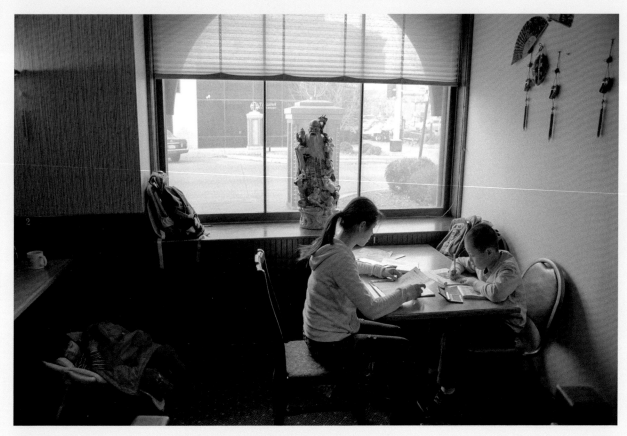

Fargo, North Dakota

AFTER MIGRATING from Fujianto to Brooklyn, Xia and her family have settled in Fargo. She has been working at King House Buffet for eight years, and when she's not seating customers or cashiering, the owners allow her to use a part of the dining area to keep an eye on her young daughter and help her eight-year-old with his homework. Since Xia uses the kitchen check to write the orders for the cooks, the Chinese characters are faintly visible underneath her son's vocabulary list.

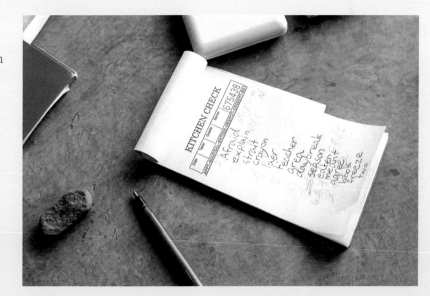

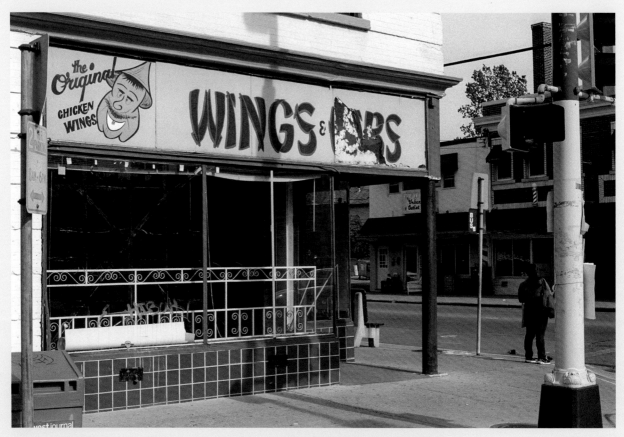

Minneapolis, Minnesota

I LOVE WINGS (pun intended). The best, for my money, was Shorty & Wags Original Wings, which had been on this corner for over thirty years. The tired-looking owners (perpetually behind the counter and in the kitchen) were white, the clientele mostly black, and I was always the only Asian in the room. There are few things that transcend race, a really good chicken wing joint being one of them.

A couple of weeks after returning from a China trip in 2011, I was saddened to find out that after a three-decade run, the owners had closed shop and retired. I drove by to pay respects and was startled to see this grinning caricature. The Shorty & Wags facade had been stripped to reveal the signage from the previous wing joint. The coolie hat–wearing, cross-eyed, buck-toothed Chinaman seemed a holdover from the not-so-long-ago, nostalgic, pre–post-racial era of my youth.

We've come so far. In popular culture we've evolved from Mickey Rooney–esque caricatures to kung fu classics, nerds and geeks who never get the girl, and crazy, naked Asian guys who jump out of car trunks. Thank God for Jeremy Lin.

Guangzhou, China

CHINESE ARE KNOWN to eat some pretty crazy things. I've tasted boiled chicken feet, stewed pig brain, sliced cow's tongue, and bird's nest soup, but it wasn't until I got to China that I was able to enjoy deep-fried sea eel. In Guangdong Province, where my family is from, it is said that the Cantonese are known to eat anything that flies, except airplanes, and anything with four legs, except tables.

So it wasn't surprising, I guess, to find this recent social media thread reminiscing about my father's restaurant, which closed in 1972:

Ϙ Didn't the restaurant get closed down once for catching pigeons out the back door and serving them up on the menu?

Ϙ I heard it was cats and dogs but my Dad said it was all bull to keep young people from hanging around down there.

Ϙ A guy used to set traps on the roof of our warehouse across the street and catch pigeons. When he caught them he would go out the Michigan St door and right up the steps and into Joes restaurant. He would not come out with them.

Ϙ The rumors of pigeons and cats in their food were BS; they were common for Chinese restaurants because no one really knew all the ingredients in the various dishes.

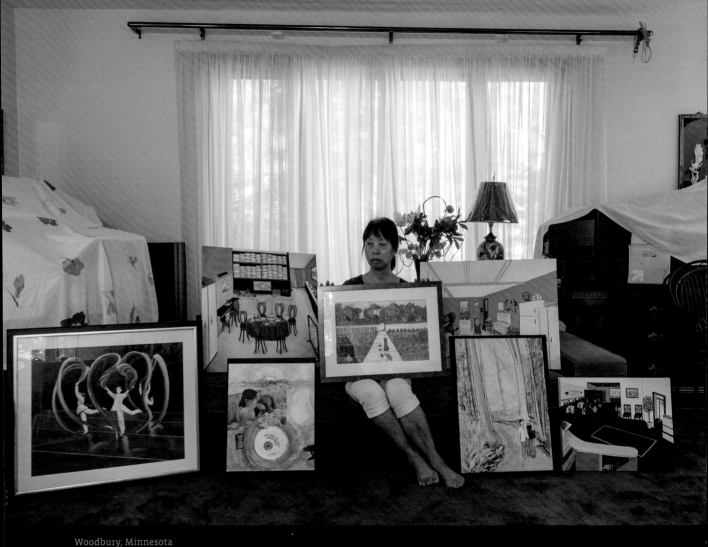

Woodbury, Minnesota

The painter

Elinor lives with her husband in a large house in Woodbury, an eastern suburb of St. Paul, which seemed even emptier after her two daughters grew up and moved out. When Elinor was a child, she told her mother that she wanted to be an artist. Her mother replied, "Better to do something practical." So Elinor became a lawyer. Now, however, she is retired and pursuing painting full tilt, taking classes and exhibiting her art.

Her paintings, created from her memories, reference various Chinese-ness moments in her life. The vertical scene by her feet depicts two figures; the one in the white shirt is her gay cousin, who never came out. This cousin died several years ago.

As an ABC (American-born Chinese), Elinor believes she is more Chinese than any of the friends she grew up with in Milwaukee, which had a large Chinese community due to its proximity to Chicago. All of her Chinese friends married someone white, while she married a Chinese man from Hong Kong. She has a strong sense of identity and pride in being Chinese, instilled by her immigrant father from Guangdong.

Yet, in the moments after she became a mother, when the nurse placed her firstborn on her belly, Elinor remembers being taken aback by the baby's appearance: her daughter was Chinese. She had unconsciously expected her baby to be white. It took five or ten seconds to digest why she would think that, before realizing that her daughter was Chinese, of course, because she was Chinese.

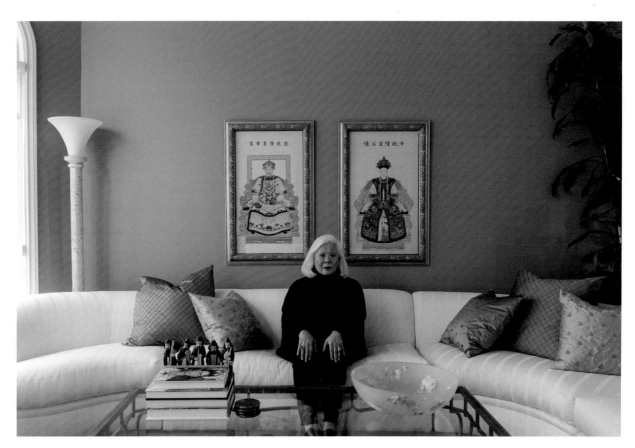

North Oaks, Minnesota

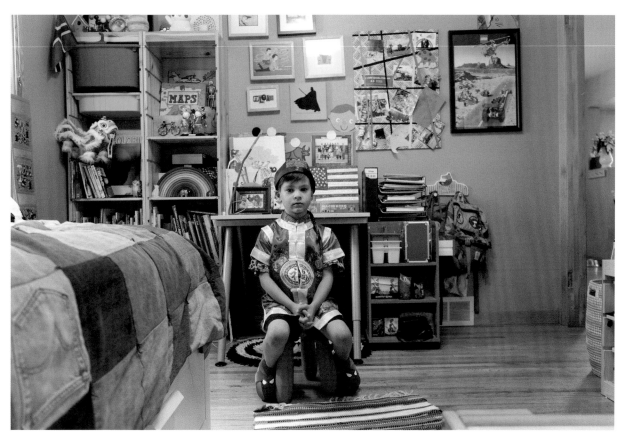

Minneapolis, Minnesota

"I've forgotten that you're Chinese"

(*Previous spread, left*) I met Judy several years ago when she walked into my Third Place Gallery to buy a photograph as a gift for the retiring head of one of the many nonprofit organizations she works with. I had my work-in-progress Chinese-ness photos on the wall, and it didn't take too long before we started trading Chinese-ness stories.

Judy tells her own story.

"I was born and raised in St. Paul with my eight-minute-younger identical-twin sister, Joanie, our sixteen-month-younger brother, Richard, and our five-year-younger brother, David. Our first language was Cantonese, the dialect of our immigrant parents. At age four, when Joanie and I started kindergarten, Daddy thought it would be best that our family speak only English. He reasoned that to get ahead in America and not be stuck working the punishing hours he put in as a chef, we needed to follow the adage, 'When in Rome, do as the Romans do.' So we did, and the result is that none of us speaks or reads Chinese.

"All of us kids embraced the idea of English-only because we could now communicate with newfound school friends while, at the same time, we could give the playground bullies one less reason to taunt us. Our mother, on the other hand—not so much. Mama immigrated to the US at age nineteen, and she retained her thick accent during her entire life. She was able to do so because she spoke Cantonese during her phone calls with her Chinese aunties and when she played mah-jongg every Sunday night with her Chinese girlfriends. Our language evolved into a mishmash of English nouns and pronouns and Chinese verbs and adverbs, aka *Chinglish*. Mama could confidently say Ben Gay, fish oil, Sears, Wards, Dayton's, the Golden Rule, the Emporium, Red Owl, Applebaum's, Revlon, and pizza. She loved searching store ads in the newspapers, and her favorite word was 'SALE.' She

also knew how to read bank ads, and on any given day she could tell you which financial institutions offered the best CD rates. She knew the value of and could even explain the concept of compound interest.

"I grew up wanting to look like what I was looking at, which, in my middle-class neighborhood, meant white or Jewish. Or, ideally and longingly, one of the Breck Shampoo Girls, who stared up at me from the glossy pages of *Seventeen, Mademoiselle,* or *Glamour* magazines. New acquaintances would ask, 'Why don't you sound Chinese?' Some people would say, 'You don't look Chinese. You look Polynesian or Hawaiian.' Friends would say, 'You don't act like a Chinese person. I've forgotten that you're Chinese.' I truly think that these people were trying to pay me a high compliment, and they wanted to tell me that I had achieved their loftier stature. There is a name for this condition: Twinkie. Yellow on the outside and white on the inside. To this day, I still wonder if it is a compliment and why these people felt compelled to say it. Interestingly, in discussing this with my father, he was more concerned that the lines between Asian cultures were getting blurred as more Vietnamese, Hmong, Eastern Indian, Cambodian, and Karen people immigrated to St. Paul, adding to the already-established Chinese, Japanese, Filipino, and Korean populations. Asians and Pacific Islanders were now lumped together into one race group. We are no longer Chinese. We are Asian. Totally unacceptable to Daddy! So ironic, for the man who wanted us to speak only English.

"I married Edward forty-five years ago. He is white. We had been dating a while when he decided that I should meet his parents. He told his parents that he was seeing someone and that I am Chinese. His mother's first question was, 'Does she speak English?' The joke in my house: yes, she does, but she doesn't speak Chinese.

"To help furnish our first house, we engaged an interior designer from Gabbert's. With her help we chose a contemporary look that included one piece of Chinese art. It's a large picture, 44" by 37", of a horse from the Tang Dynasty. We thought that it was perfect because Eddie was born in the Year of the Horse. This picture has inspired many of the furnishings in our current home: Chinese artwork, paintings, silk screens, antiques, and Cloisonné eggs acquired on my trips to China. (I'm always spotted there as an ABC, American-born Chinese. How do they know that?) It's not as Chinese-kitschy as my childhood home, which was mostly decorated with calendars from Chinese noodle vendors and fake jade mixed with some real jade and porcelain. I am very thankful that Eddie has never had any interest in the Early American décor that he grew up with.

"I sometimes think that my Chinese-ness will disappear from our family. Our only son, Craig, who doesn't look Chinese, married Amy, a woman with a Scandinavian heritage. Their daughters, Lyla and Fiona, don't look Chinese either. I'm okay with that because we all share the commonality of being Minnesotans, and we can celebrate our Minnesotan-ness together.

"In Wing's photograph, I am in my living room, surrounded by silk screens of a Chinese emperor and empress, a grouping of five wood-carved Jewish klezmer musicians, a Scandinavian bowl, and a stack of art retrospectives with Frida Kahlo on top. It's the perfect juxtaposition of my life! Wing's Chinese-ness project made me examine and reexamine who I was, who I now am, and how I got here. I'm extraordinarily grateful to him for this."

The wanderer

(*Previous spread, right*) A native Minnesotan, Stian is a first-grader who speaks and writes exclusively in Chinese at school but at home talks to his mom and dad in English, as they don't understand Chinese. He is an ethnic mix of Indonesian, Eastern European, Jewish, Norwegian, and, yes, Chinese. He doesn't read English yet, so he plays *Minecraft* in the Chinese-language version.

Samantha, his mom, said that her Chinese Indonesian mother's biggest regret after emigrating to America was not teaching her children the Indonesian language. She didn't want them to have an accent. So Samantha jumped at the opportunity to enroll Stian at Yinghua Academy, the first publicly funded Chinese immersion charter school in the United States. Its students speak and write exclusively in Chinese until second grade, when English is slowly introduced.

Stian's father, Dan, comes from a long lineage of Norwegian Lutheran farmers, while Samantha, whose father was an Eastern European Jew, was raised in a multicultural, interracial, interfaith family. With their own family, Samantha and Dan want to blend their ancestries, cultures, faiths, and family traditions and make their own rules. Stian, whose name means "wanderer" in Norwegian, wants to learn Japanese next, because his younger sister has a Japanese name, Ayumi, which means "walks with grace."

Philadelphia, Pennsylvania

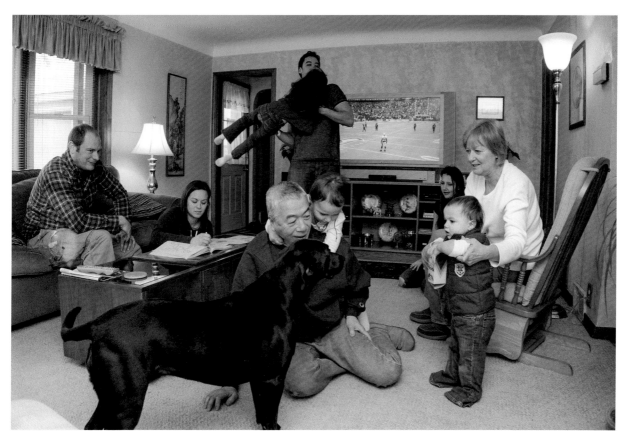

Little Canada, Minnesota

Chinese-ness + Latinx-ness

(*Previous spread, left*) Jeannie and her husband Edward parallel each other in many ways. Both are the oldest of three siblings, are American-born, and are the children of immigrants. Her dad, a paper son* who grew up in Chinatown in Washington, DC, and her Hong Kong–born, Catholic-raised mom were both very strict. Their ideas of what it was to be a good Chinese daughter were imposed on Jeannie early and often: excel at school, be a doctor or lawyer, make a lot of money, and get married. Problem was, she wanted to be an artist.

Jeannie was accepted at a prestigious high school for science and technology in northern Virginia, but she rebelled and skipped classes. To Jeannie, her behavior was not so bad compared to that of her friends, but to her parents, she was crazy. Her father was a disciplinarian and not prone to giving fatherly advice. The only words of wisdom she remembers from him were to focus on college, study hard, and let a man find her—that she should not try to find him.

Edward's father is from the Dominican Republic and migrated to Puerto Rico, where he had an older brother. This was during the Vietnam conflict, and since Puerto Rico is a part of the United States (as an unincorporated territory), Edward's father was drafted and served two years in Vietnam, even though he couldn't speak English. After serving, he moved to New York and met Edward's mother, who is from El Salvador, at an English as a Second Language (ESL) class in Queens.

Like Jeannie's parents, Edward's mom also wanted her child to become a lawyer. Instead, he dropped out of college in Miami after running out of financial aid. He did odd jobs as a doorman, assisting DJs, and working in nightclubs. One night at a spoken word event, on a dare, he wrote something on a napkin and went on stage. He has been writing ever since.

Shortly afterward, Edward moved back to New York and became part of the spoken word scene there. Jeannie was also in the city, working for the Asian American Writers' Workshop, a prominent nonprofit literary arts organization. Some mutual writer friends introduced them to each other, another parallel they joke about: Jeannie's parents' marriage was "sort of arranged," while Edward's introduction to Jeannie was "arranged by friends."

Jeannie was worried how her parents would react to Edward not being Chinese. She never confided much with her parents about any of her previous relationships. Jeannie and Edward were living together in Brooklyn when she decided to introduce him to her parents. It went well, especially when Jeannie's mom learned that Edward was raised Catholic.

For Jeannie and Edward, Chinese-ness and Latinx-ness is something they try to instill in their two children, with books, with cultural festivals, and by celebrating things that they did themselves when they were growing up.

* "Paper sons" and "paper daughters" are terms used to refer to Chinese people born in China who immigrated illegally to the United States by purchasing documents fraudulently stating that they were blood relatives of Chinese-Americans who had US citizenship.

Not at home in his home state

(*Previous spread, right*) For much of his life, Rich has not felt completely at home in his home state of Minnesota. He was born in Frogtown, a mostly African-American neighborhood bordering the state capitol building in St. Paul, and he is the younger brother of Judy (p. 24). In kindergarten he was the only Asian in the school, and his first best friend was black. Then in third grade his Chinese immigrant parents moved the family across the freeway to a mostly white neighborhood where he was, again, the only Asian in the school. In middle school a Japanese girl showed up, and when he tried getting to know her it was clear "she didn't want anything to do with another Asian."

But it wasn't until his mid-teens that he started feeling uncomfortable and noticing that people looked at him differently. He worried about what his neighbors thought when they heard his mom yelling at him in Chinese when he got into trouble. And it seemed like he got into trouble a lot because she was always yelling at him. He hoped it was because he was the oldest boy and not that he was a bad son.

In high school he got in tight with a group of white guys ("what you'd call a gang nowadays"), and they all looked out for each other, which was especially important because this was in the late sixties during the Vietnam War, and schoolmates were calling him "chink" and "slant eyes." He tried to ignore their taunts, but that didn't always work. Once, when he was standing in his own front yard and his friends weren't around, two kids he knew from school walked by and started saying racial stuff to him. One of them hauled off and punched him.

When he was in his senior year of high school, his dad got him a job in the kitchen at the Nankin Café, an iconic restaurant in downtown Minneapolis. There's an irony in this. When he was younger, he had asked his mom to teach him Chinese. She thought he should only speak English so he could end up with a better job than cooking in a Chinese restaurant like his dad. He started off as a fry cook, graduated to the broiler, and "got along pretty good with the Chinese cooks." It was hard work, but he enjoyed it, and for the first time in his life he was a part of a Chinese community. That ethnic oasis didn't last very long though.

He regrets not knowing how to speak Chinese. He did as he was told and went on to have a career as an engineer, settling in Little Canada, a town north of St. Paul that celebrates its French Canadian heritage. Now a proud grandfather, in the photograph he is surrounded by his wife and their son and daughter with their spouses and children.

For the first time he blended in

Both of Rich's parents are from Toisan. After his mother had passed away, he went there for the first time in 2007 on a family trip. He and his wife, with his wife's sister and his daughter, met up in Toisan with his father and his two sisters. It was a healing trip in many ways. He finally met his mother's sister, who reminded him of his mom. Just by looking at her, "I knew she was my aunt." It was a bit shocking, though, when he saw displayed, on the walls of her house, the photos his mom had sent her over the years of him and his siblings growing up.

He had never been able to relate to all those stories his mom had told him, while safe in their St. Paul home, about her difficult life in China. They were just stories. Being there and seeing the hardships the family faced gave him a better understanding of where he came from. "Mom would have been proud," he said. He returned to Toisan a couple of months later with his son and daughter-in-law, so they "could connect with their history and understand why we turned out the way we did."

After his father passed away, Rich feels that he has "slowly drifted away from his Chinese-ness because his parents were the ones who tied him and his siblings to the Chinese community." He remembers long ago when his dad tried to get him into a Chinese social group and took him to youth parties, but he couldn't relate to the other kids at the time. Now he laments not having any Chinese friends and having been "Americanized" and worries about losing his Chinese-ness, "but worries more for the next generations to come."

His plan is to go back to China again, maybe learn some Chinese so he can communicate. Being in China made him feel, for the first time in his life, that he blended in and people didn't stare at him. Instead they stared at his wife. When they were in Tiananmen Square, Chinese people kept coming up to her and her sister asking to take pictures. "Because they're blonde, I guess, they thought they were movie stars or something," he said. "Even the soldiers on the square were staring at them so much, I could've robbed a bank, and they wouldn't have known."

CHINESE-NESS-ISMS #1

" My mom gave me a short haircut and often sent me to school in homemade bib overalls, never a dress, because we couldn't afford anything else. I remember one day in kindergarten lining up to the girls' bathroom, and the teacher tried to put me in the line for the boys' restroom. I couldn't even tell the teacher in English that I was a girl. But I learned English pretty quickly after that. "

—A woman, now retired, born in Minneapolis, whose parents immigrated from China and didn't want her to speak English at home because they were afraid she would forget how to speak Chinese

" My son-in-law grew up in Bloomington, Minnesota. My daughter and him met in high school. They're in Seattle now, but whenever he comes back to visit us, he says his two *musts* are to eat Minnesota chicken chow mein and White Castle hamburgers, which you can't get on the West Coast. You know, the kind of old-fashioned chow mein with chicken strips on top over crispy noodles that is mostly made of celery. "

—A mom who is first-generation Chinese

" Last year when I was in fifth grade I met this other person who was Asian and I hoped she was Chinese, so I wouldn't be the only one. But I never found out if she was or not. It makes me feel kind of special that I'm the only one in my class who is Chinese. Lots of people in my school are Norwegian. "

—A Minnesota-born student whose father is Chinese and mother is Norwegian

" Grandpa was a big fisherman. I remember catching my first sunnie. He'd always cook for us. He would make beef and broccoli. Shrimp in lobster sauce for special occasions. He lived with his third wife at the time and they always spoke Cantonese to each other and it seemed that they were always arguing. Later, when we visited our Chinese relatives in Philadelphia and Boston, they spoke the same dialect and didn't seem angry. That's when I realized that that's just the way the language sounds! "

—The granddaughter of Chinese immigrants born in Minnesota

Minneapolis, Minnesota

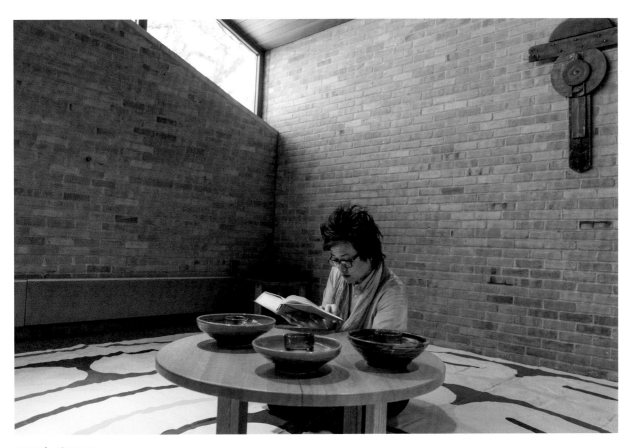

St. Paul, Minnesota

He called himself Mike

(*Previous spread, left*) I was in a crowded bar, but one man stood out right away, and not just because we were the only two Asians in the place. I had seen that kind of pigtail on an Asian man only in old westerns or kung fu flicks, never in real life. He was born in Albuquerque, New Mexico; he grew up watching all kinds of Chinese movies, and he thought the haircut was cool.

His parents named him Ming Jinn, but on the very first day of kindergarten his Chinese-ness brought him pain. When roll was called, he was so ashamed of his strange-sounding name, seemingly hard to pronounce, that he decided on the spot to call himself Mike. On his website, he is Mike Tong, pastor for Neighborhood Outreach in downtown Minneapolis.

Recently, he has started to introduce himself as Ming Jinn. It has taken more than thirty years for him to feel comfortable with the name he was born with. That initial shame is now equaled by his Chinese pride. And so with the (gradual) blessing of his wife, as a "tongue-in-cheek way of representing my Chinese heritage," he shaved his head (he was balding anyway) in order to sport a "queue"—a cut for men derived from the seventeenth-century Qing Dynasty.

Originally the Manchurians imposed this hairstyle on the conquered Han Chinese (the major ethnic group in China) under penalty of death. Its meaning, however, shifted over the centuries, and it became the cultural norm, although in current China it would be difficult to find anyone who wears it. By the early 1900s, for Chinese coming to America, cutting off their pigtails became a symbol of rebellion against China.

And the meaning now? Ming Jinn's mother laughed hysterically. His younger sister thought it was hideous. In Chinese restaurants, he gets no reaction. Some ask if it has to do with his religion, to which the answer is both yes and no. What's interest-ing, he says, is that it's mostly Black Americans who are curious about his hair.

Mike/Ming Jinn provided his Chinese-ness in bullet points:

- Parents emigrated from Taiwan to the United States in the late 1970s.
- Raised in a Chinese-speaking home, until Pee-wee Herman, Mister Rogers, and my older brother Nathan brought English into our home.
- My siblings and I could cheat at playground games speaking in our secret language.
- I pretended to know kung fu, so no one ever messed with me. (And I still know kung fu, so don't mess with me.)
- I pretended to be good at mathematics, when actually I was awesome.
- I was the definitive expert on whether an Asian was from China, Japan, or Korea.
- I couldn't read Chinese, and still can't. I am illiterate in my own first language. On my thirtieth birthday, my parents wrote me a long letter in Chinese. I've never read it. It's painful to think about that letter. And though I could have it translated, I've kept it unread as a token of who I am. I've never written a letter, or even a single note, to my parents. I suspect that I never will.
- Entering fifth grade, I was given an English proficiency test (after all, I had only been in America since birth), and I was so nervous that I called a feather a leaf and feared that I would be stuck with "those weird kids in ESL."
- By junior high school, my family made its way to the Chinatown of the United States—southern California, where Asian-Americans were proud to be Asian-American. I was now an insider in a third culture. I was found at last.
- But coming to the Midwest in 1997 threw me back into confusion. I found myself at Moody Bible

Institute in Chicago as an eighteen-year-old Asian in a very foreign world. I had never felt so Asian in my life.

- It was not until a few years ago that I had a radical shift in my understanding of what God has to say about ethnic identity, and the dam broke. Identity should not be tied to places that will not exist forever, like land or country. I no longer need to be Asian or American or Asian-American. Heaven is my home and my identity is in Christ.

The Holy Land

(*Previous spread, right*) It is through religion that another Michael has defined and redefined himself throughout his life. He was raised in the Lutheran church in the Seattle-Tacoma area, but just before college he spent more time among Pentecostals because he felt that expression of faith was truer to himself; as a charismatic, he spoke in tongues. Several years later, he served as a youth minister in a Korean United Methodist church where all the youth spoke English. He was the only non-Korean pastor (Michael is half Chinese), but they felt he was "close enough." There, a church historian reintroduced him to the Lutheran sacraments.

With his Lutheranism reawakened, Michael earned a master's degree in Old Testament at Luther Seminary and then a doctorate at Emory University. Still connected to the Pentecostal Church, he has published widely on a variety of theological topics, has received many awards in his field, and has taught,

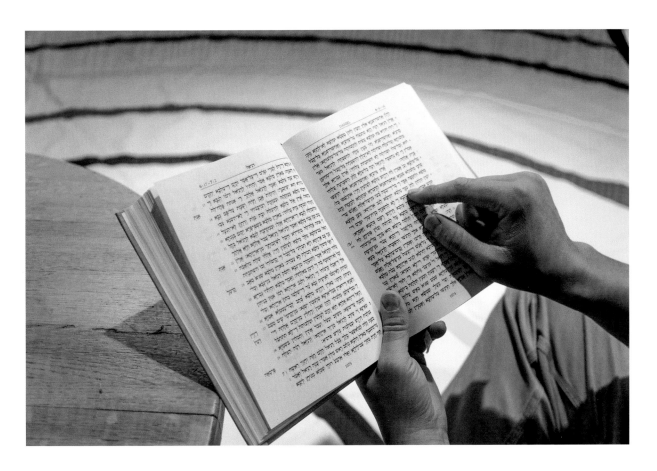

ministered, researched, and lectured nationally and internationally, including spending a year as a professor at the University of Helsinki.

Growing up, his connection to Chinese-ness was tangential, as his Chinese father never learned to speak Chinese, while his mother hailed from Arkansas. There were very few Asians in the area and only one other Chinese student in his school. The first time he felt a positive connection to Chinese culture, he recalls, was when he saw a Bruce Lee film as a teen. He has emulated Bruce's swept hairstyle in that movie ever since.

Several years ago, he went to Hong Kong for a seminar. It was the closest he has come to the homeland of his Cantonese grandparents, who settled in Nevada as Chinese restaurant owners and became prominent citizens. Going to China would be nice, he said, but if there's any pull of a motherland, it is to the Holy Land of Israel. He speaks and reads Hebrew fluently and is steeped in the meanings and poetry of the Hebrew Bible (which he is reading in the photo) and the ancient Jewish scribes. Michael feels he has an existential connection to that land and a desire to unravel its complicated history with Christianity.

I am you

For most of my career, I've been a street photographer, approaching thousands of strangers to take their images in a way where my presence is minimized or seemingly invisible. I've always thought that the best photographs look as though they took themselves. At first the goal was to make what I thought was a good photograph—the photograph as an aesthetic object. Then I started to think that the interactive process was as important, if not more important, than the resulting photograph. A photograph, no matter how good, is still just a surface description.

How, then, to create an image that goes below the surface to reveal the relational aspects of photographing strangers? Over the years I have employed a variety of concepts, expanding my documentary instincts, such as having people write revealing statements on chalkboards in response to open-ended questions like, "How do you think others see you? What don't they see?" (I call these Chalk Talks); introducing neighbors who don't know each other and photographing them collectively in each other's places; making multiple photos of one person to suggest multiple identities.

For *Chinese-ness,* I decided to add a new concept I'm calling, "I am you." Going to China for the first time made me wonder *What if?* What if my father had never left China, and I had been raised in China? Would I have turned out differently? Or what if I had not gone to college and ended up owning a Chinese restaurant like my father? Or what if I had not been the youngest and had to work sixty hours a week while going to school like my older brothers? Or what if I had turned out the way my mom really wanted, married to a Chinese woman with Chinese kids?

To get an inkling of these personal projections, I decided to wear the clothes of Chinese men whose lives I could have had if circumstances or choices had been different. Often I would photograph them, then don their clothes and give them the camera to photograph me, but not everyone wanted to be photographed.

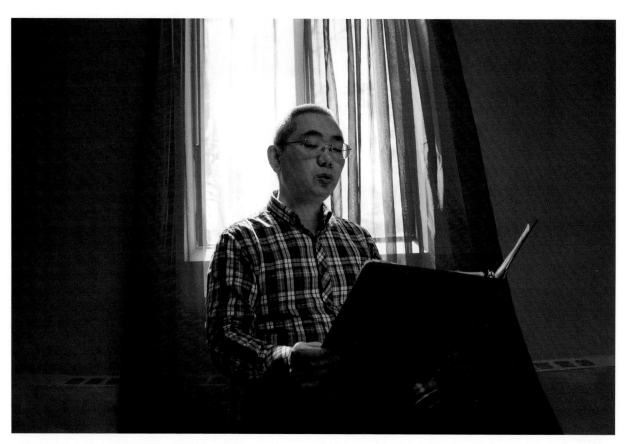

Yonglong, Minnesota Faith Chinese Lutheran Church

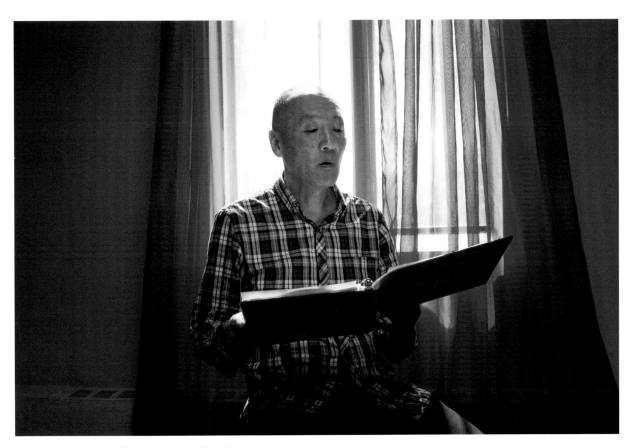

Wing, Minnesota Faith Chinese Lutheran Church

Finding Jesus in Tennessee

(*Previous spread, left*) My audacious goal was to wear the collar of the pastor for the Minnesota Faith Chinese Lutheran Church in Roseville, whose congregation is mostly comprised of Chinese born in China, but the pastor declined. I then asked a parishioner if I could wear his clothes. Another no. Finally a choir member, recently arrived from Dallas, Texas, agreed.

Yonglong grew up in JiangXi, China, where Christianity was never taught in schools and only occasionally mentioned on television, on radio, and in newspapers. His first connection to spirituality was through his grandmother, who lived in the countryside and was Buddhist "like 99 percent of the women who live there," he says. She made an altar of fruit and lit a candle for special occasions. "She was a very kind and fair person. She treated her family and her community with love and gentleness." He was greatly influenced by her.

When he was twenty-seven, with his new bride, he came to New York to be trained in a medical school. Several years later he became a researcher in a laboratory and moved to rural Tennessee, where dozens of Chinese scholars who also worked at the lab lived. It was there he found Jesus. On one of his first outings, a woman who owned the Chinese grocery store, a woman who turned out to be a sister in God, asked if he was a newcomer to town. She invited Yonglong and his wife to a weekend gathering. Since they knew nobody and were hungry for community, they went and found it was a church group, all Chinese from China. They listened to the people singing songs, reading from the Bible, and sharing stories.

"It was a unique experience, to be honest," he says. "We were a little shy, but the people were so good, so warm, and open. They showed so much care. Life wasn't easy; hardship was everywhere. They taught us how to become believers." Shortly after, Yonglong and his wife were baptized in the church. "It was a very big event in our lives and it is now fundamental to who we are." Buddhism and Christianity, he feels, share the giving of love but have different meaning in his understandings. Sometime after he converted, his grandmother in China became really ill. While talking with her on the phone, he prayed for her. "I don't know if my grandma understood what I was saying, but I feel my prayer and love for God went to her and she healed for some time."

When I photographed Yonglong, he and the other choir members in the room sang "Amazing Grace" in Mandarin. The hymnals were written in Chinese, so I quickly thought of the one Christian song to which I knew all the words, and together we sang "Silent Night."

Jesus Christ Superstar

(*Previous spread, right*) For Chinese New Year, my mom always made an altar of incense and fresh oranges on the kitchen table. When I was a kid, she would ritually stand behind me, clasp her hands over mine, and speak a prayer in Chinese; I would try to echo her words, but I did not know their meaning. An older brother had become a Presbyterian, and I grew up going to Sunday school at his church. But then, at age thirteen, I got swept up in the Jesus movement of the late sixties and became an evangelical Christian, or Jesus freak as we were called in those days. Though my mom made me pray to Buddha every year, it was Jesus Christ Superstar who became my cultural touchstone.

Two junior high teachers converted me and two buddies after we played basketball in the church gym one day. I remember us getting down on our knees and accepting Jesus into our hearts. Shortly after, we started our own group, Teen Action, and met every Thursday after school at one of the teachers' houses.

At our peak, we had a hundred spirit-drunk teens from all over Duluth jammed into that house, practicing various manifestations of the Holy Spirit such as faith healing and speaking in tongues before hitting the streets to "witness" and save souls. One spiritual high point was going into a pool hall and witnessing to a juvenile who was home from a detention center for Christmas break. Afterward we knelt in prayer on the sidewalk as he accepted Jesus.

My mom, who kept loose track of what I did outside of the house, never had a clue.

Several years later, however, the temptations of normal teenage life became too great, and I left the group. The communal feeling of shared beliefs is something I've never really experienced since—I've traded that sense of belonging for the life of an independent artist. That spiritual experience, however, has reverberated throughout my career, and I have taken photographs in hundreds of places of worship of various faiths and beliefs.

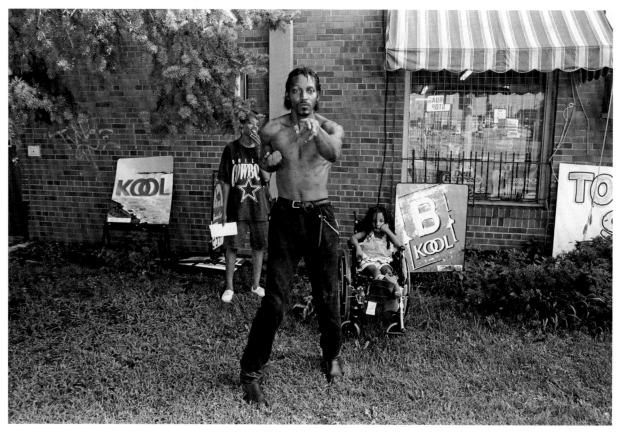

Walter, eighteen years ago

"They placed an Asian among us"

I was in my storefront gallery, working late in the evening, when I heard a knock on my front window and I waved the person in. Even before he said, "Do you remember me?" I did. I had photographed Walter a full eighteen years earlier for my Lake Street USA project, but the memory seemed fresh. I've photographed thousands of strangers, just walking up to them. Walter, however, was particularly memorable,

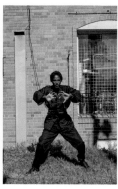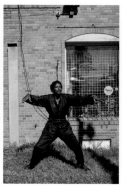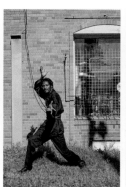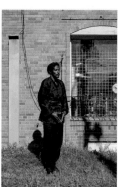

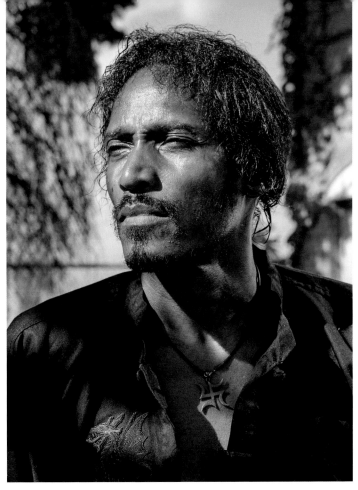
Walter today

WALTER'S PENDANT is an ancient spiritual symbol integral to Hinduism, Buddhism, and other beliefs, with multiple meanings, including the harmonious interplay of the many opposites in life.

especially with his connection to Chinese-ness. I asked if I could photograph him again in the same spot and continue the conversation we had started so long ago.

Q: What do you remember about my approach eighteen years ago?

A: I remember thinking this guy is probably some undercover police officer, and to make sure we don't suspect him of being an undercover police officer, law enforcement has placed an Asian among us to make it a covert-seeming operation.

Q: How did you become a martial artist?

A: I started martial arts when I was eleven because I had problems with local bullies. I grew up in Iowa in a little town called Waterloo and there were very few

Asians at all. There was a lot of racial tension. It took a while for them to warm up to me because they had heard so many negatives.

I've studied many styles with proficiency in three: White Crane; Wing Chun; Sil Lum or Shaolin.

I have an affinity for Chinese people and their culture because of a past lifetime. I take to it like a duck to water. I've incarnated into this physical body, but what was in the past was brought with me. I've had glimpses of being a salt merchant in ancient China, told to me by an oracle in Denver thirty years ago. I seem to have an aptitude for things Chinese. It's more natural for me. In fact, I think that if you gave me the right makeup, I wouldn't have a hard time portraying a Chinese character at all. I guess I'm in the wrong skin.

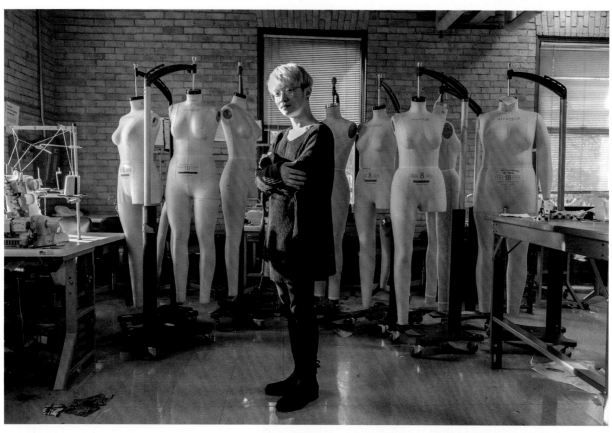

Minnesota

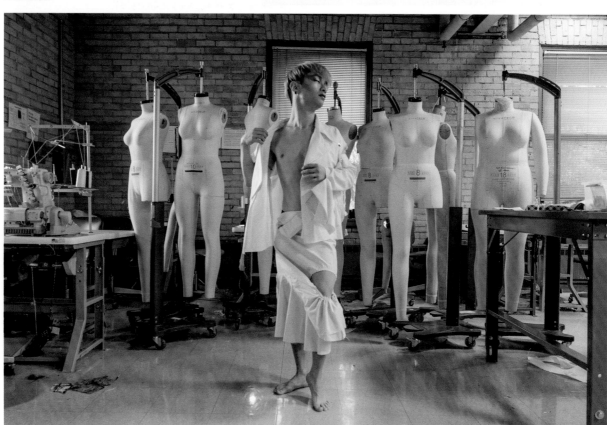

The designer

When Charlie had his final exam in middle school in China, he decided, for the first time, to wear makeup. He didn't really want anyone to notice; he just wanted to look better, so he put on a little eyeliner. When a friend noticed, he denied it. It wasn't until he left his home and became a college student in Minnesota, majoring in apparel design, that he felt comfortable wearing makeup in public. For the photo on the bottom, though, he wanted to look more dramatic, and so we hired a professional makeup artist, something he had never done before. It was an opportunity, he said, "for me to look . . . the gayest!"

Back home in China, if you stick out for any reason, you get talked about, he says. To be publicly gay when he was growing up seemed almost unthinkable. Gayness existed only as a joke. "Like if two guys were hanging out, people would say, 'Ha ha, you are gay.' It was pretty normal to see guys humping each other to be funny. But if they were really gay, people would think it's weird. It's as though gayness didn't really exist." Charlie knew he was gay in the fifth grade, but it was only in the last two years that he has declared it publicly (although not yet to his parents in China).

After he arrived in Minnesota, he felt more freedom to dress up, and then he worried that he was overdressed because "no one ever dresses up here!" In the Midwest, he says, "when you are dressed up, people question whether you are straight or not. For straight men to justify being well dressed, we had to develop the term *metrosexual*." His goal is to make gender-neutral or all-gender clothing; in the bottom photo, he is wearing one of his uncompleted creations. "I want people to look at a clothing item and think, 'I can wear that; it will look cute on me,' instead of thinking, 'That's a men's item' or 'That's a women's item and I can't wear it.'"

Charlie feels he is slowly gaining confidence with his individuality. "I didn't just struggle with my gay side. I struggle with my Asian side. If you try to get involved with the gay community, it's usually pretty white. It's less acceptable to be gay if you're a person of color." His goal now is to be a global citizen, to work, travel, and live in different countries around the world.

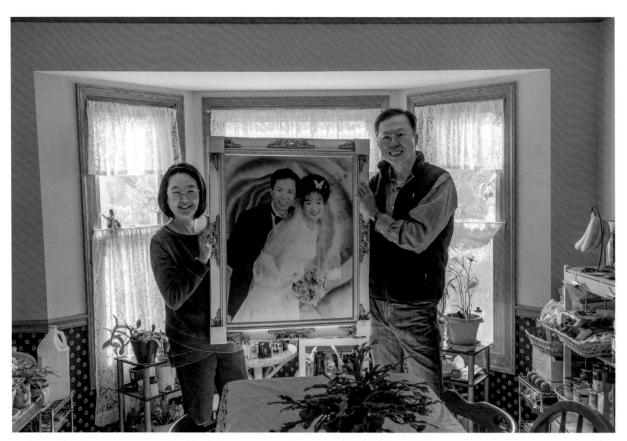

Bill Liu and Ling Lee, Naperville, Illinois

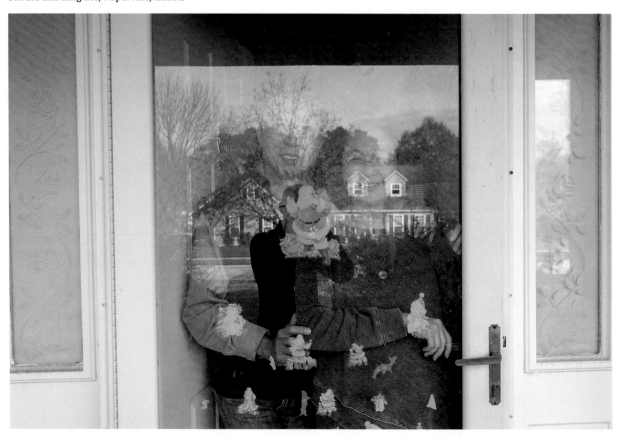

Big Mac and Coke

When Bill Liu left Taiwan for the United States in 1982 to attend graduate school at the University of Oklahoma, his mom made him pack a rice cooker because she was worried he would not be able to buy one here. Cooking rice, though, was the least of his worries. Although he knew some English because it was taught in school in Taiwan, when he started his college classes he "was in shock" because he couldn't understand what the professors were saying and "felt like a mute" because people couldn't understand him. It was not about fitting in, he says, "it was about survival."

Bill: "The first week at the university I went to McDonald's and tried to order something but nobody behind the counter understood me. They just looked at me with blank faces and said, 'huh?' So I went down the menu, pronouncing items as best as I could, and it wasn't until I said 'Big Mac' and 'Coke' that they finally understood. So I subsisted on Big Mac and Coke the first two weeks before the dorm opened. McDonald's has a special place in my heart, and every several years I will gorge on a Big Mac and Coke just to get my fix."

Also in that first week, he summoned the courage to ask his environmental chemistry professor a question, using his rudimentary English. The professor responded, "I don't think you can handle the requirements in my class." Depressed, Bill shared his predicament with the retired department head, who asked his PhD student Andy, a Hong Kong native, to give Bill a pep talk. Andy's older brother, after earning a doctorate in civil engineering from the University of Oklahoma, had opened five Chinese restaurants. Andy reassured Bill, "All Chinese students can handle the English requirements after a while." At which the retired professor quipped: "I should not take Chinese students anymore. You guys all open Chinese restaurants after graduation, anyway."

Seven years later Bill graduated from the University of Illinois with a PhD in environmental engineering and then went on to also receive an MBA in marketing, finance, and international business from Northwestern University. His wife, Ling, whom he met after college, is also from Taiwan and holds a PhD in food chemistry from Michigan State University. She is now a food scientist; Bill is a global consultant and lecturer, working to connect Chinese and US businesses. Several years ago, the mayor of Naperville appointed him chairman of Chinese community outreach, an organization that builds connections between city leaders and members of the growing local Chinese community.

In one photo Bill and Ling are holding their wedding photo, taken twenty years ago in Taiwan. In the other photo, they are standing at the front door of the house where they live with their teenage daughter and son, who are fluent in Chinese. Before the kids turned ten, they attended weekend Chinese schools religiously. After several years, with Bill's permission, they both stopped going—with one condition: they agreed to speak Chinese at home. They still do.

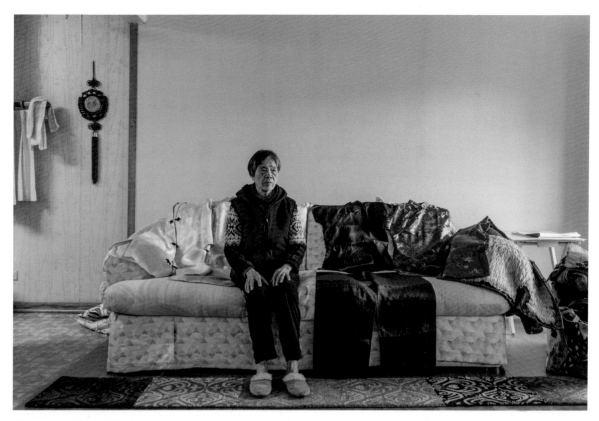

Chinatown, Chicago, Illinois

Chinatown, Chicago, Illinois

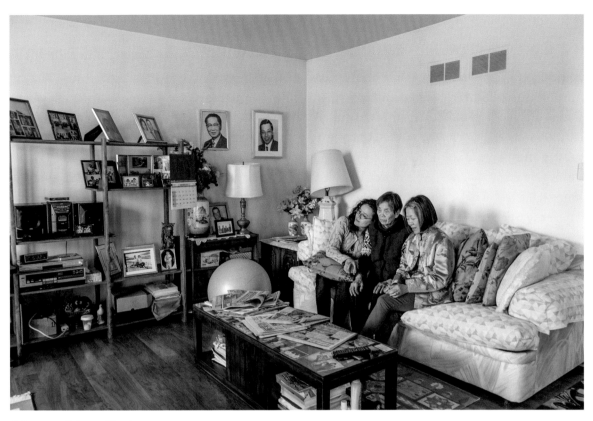

Chinatown, Chicago, Illinois

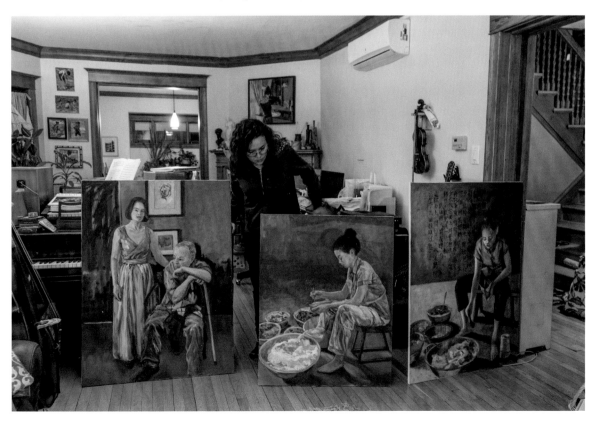

Oak Park, Illinois

Three generations of Chinese-ness

(*Previous spread*) Grandma has seldom ventured outside of Chicago's Chinatown, her home for more than fifty years. Her husband, a paper son from Toisan, arrived at Midway Airport in February 1960, and two years later, after he made a bit of money and managed to borrow some, she and their five children followed. He worked the rest of his life in Chinese restaurants and never learned to speak English well. She did mostly factory work with other Chinese women and speaks little English, even though she had diligently spent many nights in bed with her ESL books, reading aloud, sounding out words. Without guidance, she never got far with pronunciation or proficiency.

Several years ago, her husband passed away. She is now retired and lives by herself, practicing tai chi with others in the park every day. For years she's been keeping track of her blood pressure, writing it down daily, although she doesn't do anything with the readings and doesn't show it to her doctor. Notes that her husband had written are scattered around the house: telephone numbers, weather temperatures, vocabulary words, other jottings. She sees his writing throughout the day.

Her daughter Nancy Fong, the fourth child, came over as a Chinese-speaking two-year-old and now lives in Oak Park, a first suburb west of Chicago where there are few Chinese. All of her siblings are fluent in English, although the eldest brother still has an accent. Nancy's life has been devoted to art. After receiving a BA in studio arts from the University of Illinois, she exhibited widely and taught art to people of all ages, from preschoolers to seniors, including people with mental illness. Nancy tried to teach the Toisan dialect to her three children, but they managed to learn only a few words and phrases.

Alizarin, Nancy's oldest, is often the subject in her mom's paintings, doing Chinese things like ribbon dancing or calligraphy or making dumplings—things that she didn't do in real life. She is now a visual artist and an activist involved with a variety of groups, including the Million Artist Movement and the Yarn Mission.

As a student at Macalester College in St. Paul, Alizarin had an openly queer Asian professor who was her first role model for raising consciousness around Chinese-ness with queer-ness. This professor introduced her to the intersectional term 同志 (pronounced tóngzhì), which means "comrade" but is also slang for "homosexual" in Taiwan, Hong Kong, and China. Since 1989 the term has been reappropriated by Chinese queer communities, and it now resonates with a redefined revolutionary intent. Since then Alizarin has started more openly using her Chinese name—Bo-Sum, the name her mother calls her—and she has added the paper name of her grandfather, Fong. Alizarin gradually came out to her mother a couple of years ago. She recently was in Taiwan studying Mandarin before moving to the Bay Area, where she now works at Chinese Progressive Association, an organization that builds power with the working-class Chinese immigrant community in San Francisco.

For the photograph on the upper right, Nancy decided to wear a traditional Chinese jacket. When I asked her mother if she had any traditional Chinese clothes, she pulled out a variety of beautiful outfits that she brought when she came to America, none of them ever worn. When I asked if she could put one of them on for the photograph, she scolded me in Toisan hua, using a phrase that meant to do so would be frivolous. She reminded me of my mother, who said that to me a lot when I was growing up, as it seemed to apply to just about everything I liked to do.

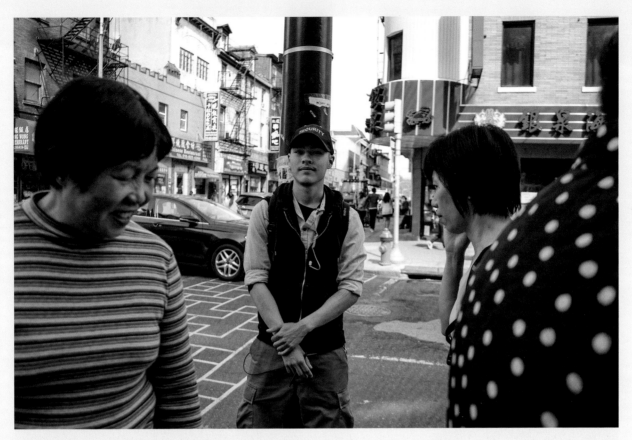

Jason, Chinatown, Philadelphia, Pennsylvania

"I'M FROM SOUTHWEST PHILLY. My Chinese heritage came from my grandpa on my mom's side. I really don't speak much Chinese but I'm learning from my friends. I took an interest in learning Chinese because if I didn't know how to speak Chinese I wouldn't really consider myself Chinese. My grandfather is from somewhere in China and my parents were born in Vietnam. My grandmother is Vietnamese and French.

"'What are you?' I get that question a lot. I'm like, everything. People mistake me for Mexican or Puerto Rican. I still don't see how. Other people say, 'Are you white?' I'm like, yeah. 'What kind of white?' I say, 'I don't know. Vietnam War–white?' I'm proud to be Asian in general."

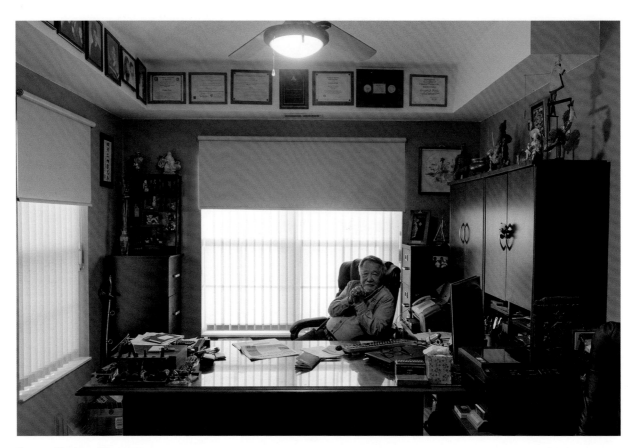

Gregory, Hopkins, Minnesota

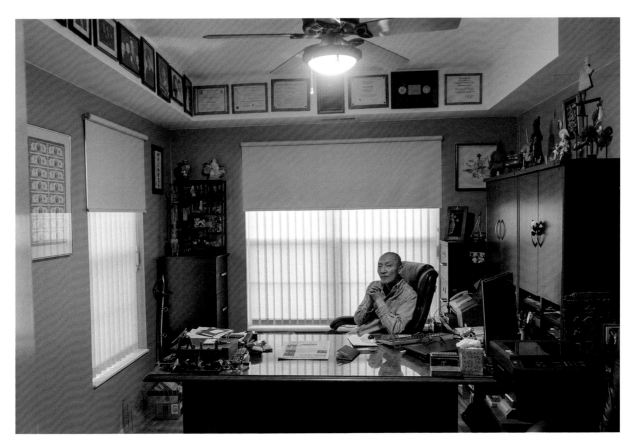

Wing, Hopkins, Minnesota

"Reborn Chinese person"

(*Previous spread*) While waiting for takeout, part of the Chinese restaurant experience is browsing through the variety of ethnic newspapers stacked in entryways or scattered on chairs. Early in my career, when I was a freelance reporter, I had even worked for some of the publications, such as *Asian American Press*. I would flip through the ones in Chinese to look at the photos. The largest piles often belonged to *China/Insight*, an English-language monthly. Its masthead claimed, optimistically: "Fostering business and cultural harmony between China and the U.S."

Before Gregory Hugh founded the paper in 2001, he had spent most of his life trying to understand his own relationship with those two cultural forces. The eighth of twelve kids, he grew up in the "ethnic ghetto" of Chicago's Chinatown, speaking colloquial Cantonese.

His father owned a Chinese take-out place on the North Side, and much of his adolescence was spent riding the L-train to work in the family business. When his immigrant parents enrolled him at a Chinese language school at age twelve, he hated it because he "wanted to be American." Now, lamenting that his children never learned to speak Chinese, he feels that he "screwed up" and should have learned more.

In Chinatown he went by his Chinese name, Guy Gee Hugh, until he started to attend the Chinese Catholic Mission School, located within the Chinese enclave but a world away culturally. His sister decided he needed a good Catholic name and gave young Guy Gee the name Gregory, worthy of a pope. There he became exposed to "what normal American guys do." But the big change came when he went to a small Catholic college in Iowa (he and a brother are the only siblings to go to college) where there were few who looked like him and he became self-conscious about being Chinese.

"It was all in my mind," he says. "Most guys I hung around with didn't care, but there would be a dance in the student union and I wouldn't go because I thought I would cramp their style." To make his way through school, he worked as a waiter in Chinese restaurants and thought of being a lawyer or teacher, but he married young and "those dreams went out the window." He instead got involved in marketing and sold restaurant supplies and then lava lamps before coming to Minnesota in 1969 to become director of marketing for Fingerhut, a large mail-order catalog company. His new home was Minnetonka, where he became a "shadow of a Chinese person."

But eventually he was introduced to other Chinese-Americans, including Jack Yee, who owned one of the Twin Cities' oldest Chinese restaurants, and famed entrepreneur Leeann Chin, and he became part of a community. When China began rising as a world power in the late eighties and China bashing became popular, he became defensive and decided to start *China/Insight* to serve as a bridge between the two countries. Although he had never felt any allegiance toward China, the emergence of the motherland coincided with the personal emergence of Gregory Guy Gee Hugh. After he left Chinatown he had become what he called a stereotypical banana,* but over the years that "banana had ripened." He had become a "reborn Chinese person, where my yellow-ness was no longer a disguise. It is just what I am."

* *Banana* is a term for an Asian person who has lost touch with the cultural identity of his or her parents. It may be used pejoratively or non-pejoratively.

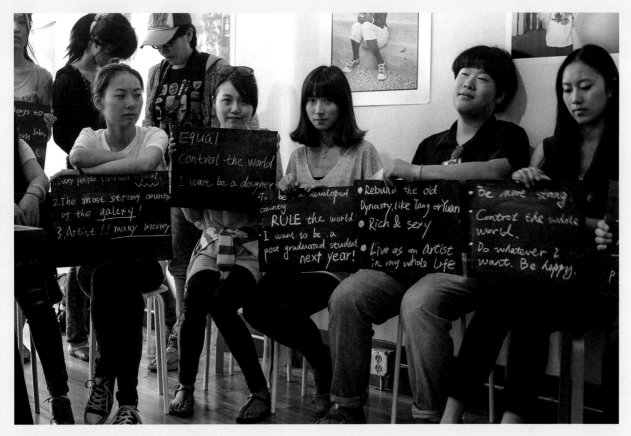

Third Place Gallery, Minneapolis, Minnesota

ABOUT TEN YEARS AGO I started thinking that no matter how good the photograph, it's still just a surface description. How, then, to create an image that would give a glimpse of what's underneath? I decided to give people chalkboards and ask a variety of open-ended questions.

These students from the China Academy of Art in Hangzhou were spending two weeks at an international study program at the Minneapolis College of Art and Design. Their professor, Piotr Szyhalski, brought them to my Third Place Gallery. I had been reading about President Xi Jinping's promotion of the "Chinese Dream," and so I decided to ask these questions. The students replied in the same order.

— What is the Chinese Dream?

— What is the American Dream?

— What is your dream?

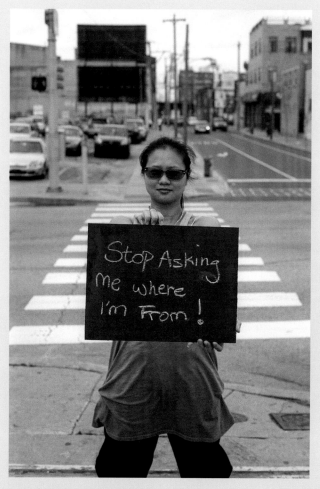

Artist, Philadelphia, Pennsylvania

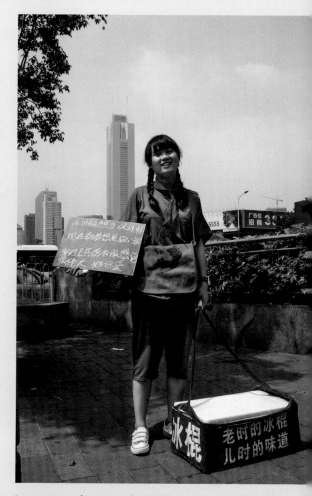

Ice cream vendor, Guangzhou, China

WHEN I ASKED Chinese-Americans, "What does Chinese-ness mean to you?" the answers were immediate. But when I asked that question in China, I would get puzzled looks, so my interpreter suggested I ask something more evocative. We decided on, "What was your dream as a child? What is your dream now?"

❝ I used to dream of being a fashion designer, now I want to be a painter. I feel great and adorable wearing the Red Guard Outfit. ❞

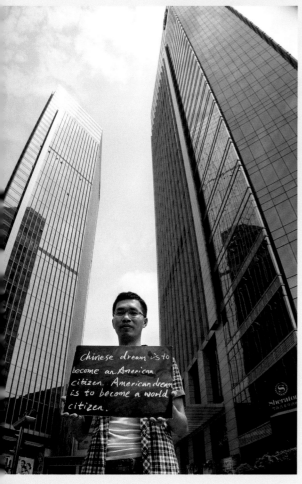

.angzhou, China

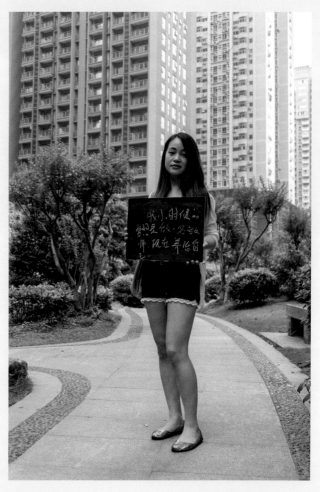

Guangzhou, China

❝ When I was young, my dream
was to be a teacher. Now, I just
think about surviving. ❞

SZ Gallery, 798 Art District, Beijing, China

First time in the motherland

The trip of a lifetime for any child of immigrants is the one back to the motherland. Mine started with a bang. I set foot in the Middle Kingdom for the first time in December 2000, arriving in Beijing for the opening of my solo show at the SZ Gallery in the internationally celebrated 798 Art District. It was the kick-off for a traveling exhibition of my work, sixty photos culled from about a dozen of my photographic projects over thirty years, that would be viewed by over a million people in a dozen cities throughout China. Way more people have seen my photos in China than in my home country.

This incredible opportunity was made possible by Arts Midwest, a Minneapolis-based organization that facilitates international artist exchange programs, with support from the US Department of State. The idea was to promote visual artists as cultural ambassadors. My role was to give people in China a realistic view of America through the eyes of a Chinese-American. I came from a place where inside I felt like those around me but stuck out; I arrived in a place where I kind of looked like everyone but really felt like a foreigner. Especially when I opened my mouth. The meager Chinese language skills I once possessed had long since eroded. People there, of course, assumed differently. And so it was with a bit of shame and cultural guilt that I had to repeatedly shake my head and say, "Wǒ bùzhīdào" (I don't understand).

I made three visits to exhibition sites over several years, giving lectures at multiple venues. Reactions from audiences varied. At Tsinghua University, one of the top academic institutions in Asia, one puzzled student stood up and remarked in English, "But you are showing us images of what America really looks like, not the rich paradise that we know it is!" Indeed. What is more distorted? Our perception of them or their perception of us?

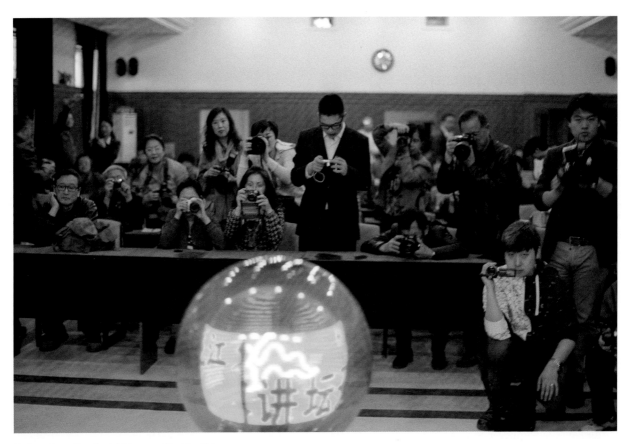

Heilongjiang Provincial Museum, Harbin, China

Are you overwhelmed?

One of the cities where my photos were displayed was Harbin, the northeast capital and tenth-largest city in China, known for its bitter winters and ice festivals. It also has a sister-city relationship with Minneapolis. Because of this fortuitous coincidence, I was not only a cultural ambassador but also an official emissary, as I was asked by the mayor of Minneapolis to deliver a letter of greeting to the vice division chief of American and Oceanian Affairs in the Harbin Foreign and Overseas Chinese Affairs Office. Being a representative of the United States was both an honor and daunting.

Just minutes prior to my lecture at the Heilongjiang Provincial Museum, I was interviewed by CCTV, the predominant state television broadcaster in the People's Republic of China, which has access to more than one billion viewers. Also preceding my lecture was an opening ceremony in which museum officials and I took part in what I was told was a standard ritual for such important events in China. We placed our hands on an electrostatic globe that, when touched, danced with tiny lightning bolts that were partially eclipsed by the barrage of flashes from the camera-wielding audience.

At one point my interpreter leaned over to me and whispered, "Are you overwhelmed?" I was.

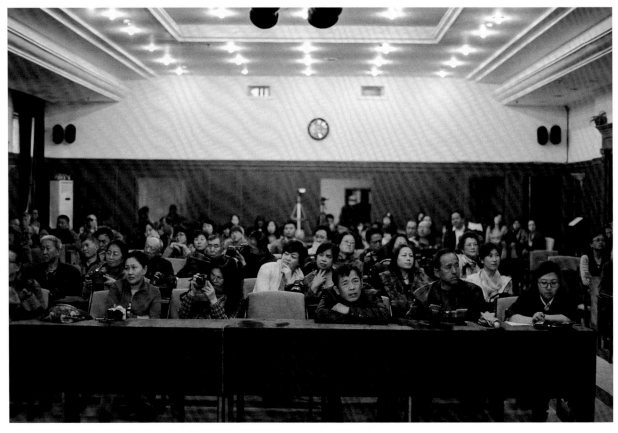

The audience during my lecture, Heilongjiang Provincial Museum, Harbin, China

DURING MY SLIDE-SHOW presentation, while my interpreter was translating my important and insightful thoughts, I took photos of the audience, whose expressions suggested otherwise. At the end, relieved, I asked for questions. One middle-aged woman got up out of her seat and spoke, her voice growing louder and louder, dramatically gesturing. As she went on, the people around her laughed nervously.

Since I had no idea what she was saying, I turned to my interpreter, who just shook his head and said he would explain later. After several minutes, guards circled the woman as she kept shouting, and they slowly escorted her out of the auditorium.

My interpreter, in a not-to-be-concerned voice, explained briefly what had just transpired, but I'm not sure if I really got it, something to do with the

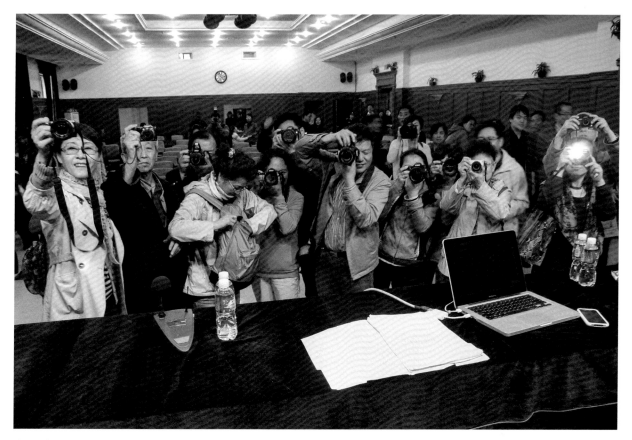

The audience after my lecture, Heilongjiang Provincial Museum, Harbin, China

dishonor of bringing an American here on the thirty-fifth anniversary of Chairman Mao's death while there is economic disparity in China and even in America people were protesting on the streets (this was during the Occupy Movement). To restore order, the director of the museum got up to speak, signaling that my lecture was finally over. To my surprise, audience members applauded enthusiastically and got up from their seats to swarm me like paparazzi.

Does speaking Chinese make you Chinese?

It would be difficult for me to encapsulate or understand the myriad reactions to my photographs and presentations in China. Sometimes I felt like a comedian dying on stage; other times the audience asked so many questions that we had to cut people off because of time. I wonder how many factors played a part: audience age, cultural relevance, interpretation issues, shyness or reluctance to question an authority figure (me), my Westernized perspective and ignorance, jet lag, differing photographic aesthetics, my overinflated sense of myself and my photos, and so on. One aspect, however, remained constant: afterward, most audience members wanted to either photograph me or do a selfie with me.

One middle-aged man hoped that I could shed some light on an ongoing debate among Chinese photographers between the pristine landscape aesthetic of Ansel Adams and the social documentary of W. Eugene Smith. "Who is more relevant?" he wanted to know. My not-well-thought-out, diplomatic answer did nothing to settle the debate.

I had another interaction with a university student who was Chinese-Canadian, born and raised in Toronto, which has a large Asian community where she didn't stick out growing up. But then in high school her family moved to the deep, rural American South, where she felt marginalized. She had been in China several years and talked about her shifting cultural identity and the difficulties of being perceived as different.

Her plan was to stay in China after graduating with the hopes of having a career as a television journalist. Even though she is fluent in Chinese, on occasion she will say or do something in front of her fellow students that signals to them that she is still a foreigner and not really Chinese, and they tease her for it. I asked her, "Does speaking Chinese make you Chinese?" She thought for a moment and then shook her head no.

Comments left on the wall of my traveling exhibit in Chengdu:

— The outside may be not as wonderful as you think. Value your life. Be satisfied.

— I think these pictures are so nice. I like it very much.

— I think too little.

— My English is so poor that I can't express what I want to say.

— Stranger in a strange land.

— You really did a wonderful job! I love your pictures!

— Every photo has its own story, about dreams, lives, unfairness—Hearts need to be moved by others. Impressive! Being a photographer is my dream when I was a child!

— A question: where is your salary from? U know, it's too heavy!

— "One thing in common" Love and Detail—Kevin

— Everyone is surprised.

— I can't believe. It's so crazy for me. We are the 99%.

— Life is the same. Our life is not different. Special pictures.

— Keep moving!

— 《情投意合小姐》这幅很朴素，但我喜欢。{The pictures are very simple, but I like it.}

— Just poor!

— 什么时候我们也会称为一道风景。{When could we become a landscape?}

— 假如能有经典段子配图就完美了。{Wish there are more jokes to go with the images.}

— Beauty comes from inside.

— 仿佛听见生命的节奏。{Thought I heard the rhythm of life.}

— Live, to get to those places.

— Everyone has his life, his own world. It just belongs to himself.

— It's reflective!

— 喜欢你，没道理。{I like you, no explanation.}

— 《姐妹》里有个美女。{There's a beauty in the image of the sisters.}

— All are the same.

— 尽情地活着，如你般。{Live it up, like you.}

— 看到形态各异的种族与人群，让我不舒服。但感受到这些都是生活的时候让我惊奇 {Saw many different races and people, it makes me uncomfortable, but it surprises me because it's life.}

— 许多作品拍摄背景介绍较为简单，致使观众不太了解其内涵，无法与摄影师产生共鸣 {The explanation for the images are too simple, makes you wonder about the meaning, it feels hard to get the artist's intention.}

— 外面的世界很精彩！平凡时代的小人物 {The world outside is amazing! Ordinary people in ordinary times.}

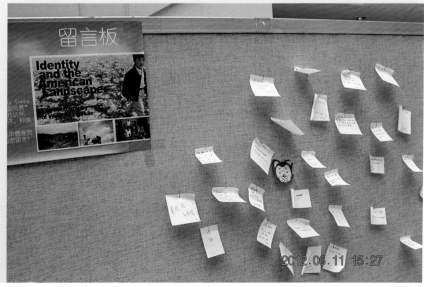

Woman's Day on Google

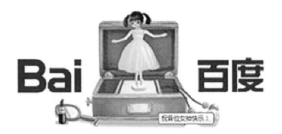

Woman's Day on Baidu (Chinese search engine)

A long way to go

When I took the photo on the left, Gai Yinan was a student at Guangdong University of Foreign Studies. A year later, after she moved to Hong Kong to enter the postgraduate program at the City University of Hong Kong, we had the following email exchange.

Why did you write that?

I think woman is more sensitive and man are more logical in thinking. I feel I am more logical in solving problems and my hobbies are more similar to man's, like watching soccer games and following some political events. However, I have to admit that when I wrote that chalkboard statement, I believed man was better than woman. But now I have changed my mind.

How does Chinese society look at women differently than men?

On the Women's Day of this year, both Google and Baidu (a Chinese search site) changed the image on their home page for the festival. In Google's image, woman can be scientist, painter, or sports players, but in Baidu's image, woman is like a doll in the box.

My mother always reminds me that she wants me to become a teacher, which is a stable job in China. She thinks if I am a teacher, I can spend more time in the family. I think many Chinese hold the same idea. A woman's happiness is closely connected to the man she marries.

Is that changing? How has it affected you personally?

Definitely, Chinese people's understanding of women is changing. It is realized that women are capable of playing other roles, not only mother and wife. I think it is common worldwide, but Chinese still have a long way to go in feminism. Because I find it is always the boys who receive job offers earlier than girls among my classmates.

Although I am not married now, I think I will spend a lot of time with my family in the future. But I will not sacrifice my own career only for my future husband and children. My own happiness is also very important.

What makes someone Chinese?

If this question was asked a year ago, I would say the Chinese value made someone Chinese. But these days, I am confused about what Chinese value is. When I was in the mainland, I thought Chinese had a sense of belonging. They like collectivism and they need to belong to somewhere. However, when I am in Hong Kong now, I find that people here value individualism very much. Everyone is treated independently.

Does speaking Chinese make you more Chinese? Is it essential?

I used to believe that speaking Chinese is essential for being a Chinese. Because language conveys culture. But when I heard the phenomenon of Jewish people, I changed my idea. Jewish people live in different countries and speak different language, but they still hold the belief that they are from the same nation. Therefore, I think language may not be very essential for national identity.

THERE WERE SO MANY things I saw in China for which I had little frame of reference. At first I thought this was a souvenir shop where you could buy photographs of famous Chinese, because I recognized Chairman Mao Zedong and his successor, Deng Xiaoping. A program assistant at the US consulate in Guangzhou, who was my guide, then informed me:

"This store sells drawings. Before the digital era, people had to rely on painters to enlarge or make copies of photos, or restore their damaged old photos, like portraits of their late great parents and so on. Nowadays, this kind of store is rare, as you can imagine its business is shrinking dramatically. I never saw such a shop in big city like Guangzhou, but occasionally I saw one or two in smaller cities."

Portrait artist, Lianzhou, China

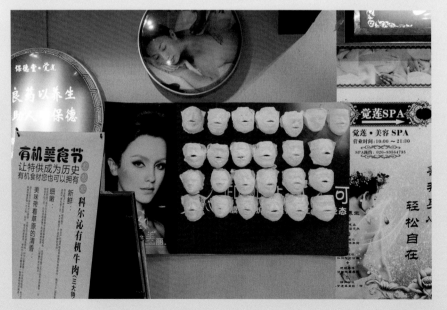

Whitening facial masks, Guangzhou, China

I FOUND AN ARTICLE on whitening online, in the *Economic Times* of India. It quotes Li Yanbing, vice-secretary general of the Chamber of Beauty Culture and Cosmetics of the All-China Federation of Industry and Commerce: "Skin whitening has a long history in Asia, stemming back to ancient China. And the saying 'one white covers up one hundred ugliness' was passed through the generations. . . This obsession with whiteness has not faded over time."

Chinese restaurant, Minneapolis, Minnesota

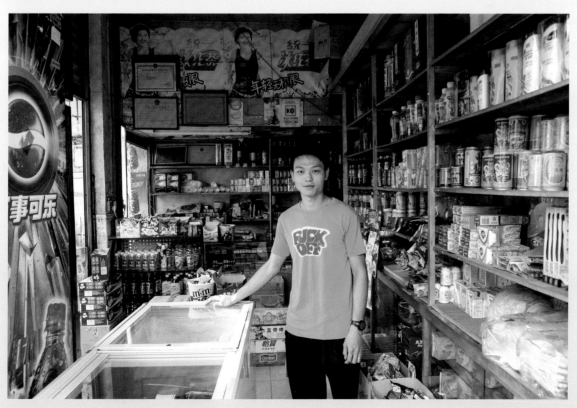

Convenience store, Lianzhou, China

Lianzhou Camera Association, Lianzhou, China

Lianzhou Camera Association, Lianzhou, China

The Lianzhou Photographers Association, estab-
lished in 2009, is the most powerful and popular
photography organization in the city, with over one
hundred members, according to their website. They
organize many events to improve the "wellness and
culture" of members, and every Chinese New Year
they take family photographs of community mem-
bers for free.

Guixing, its vice chairman—and the man whose
clothes I am wearing—has had his images published
in newspapers, and his photograph "An Old Temple in
Sunset" won third prize in a contest of the "Ten Most
Beautiful Nature Views of Lianzhou."

Lianzhou Camera Association, Lianzhou, China

AT THE ASSOCIATION'S spacious gallery, I gave a presentation to members, showing slides of my gritty, black-and-white, documentary-style photographs of everyday life in urban Minnesota neighborhoods. My work contrasted greatly with the stunning scenic views hanging on the gallery walls, and the lack of response from the audience worried me. But when I showed the photos of me wearing the clothes of Chinese men, they became enthusiastic.

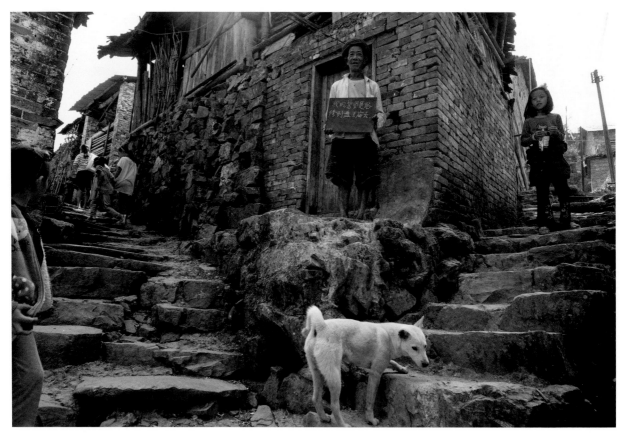

Youling Village, Guangdong Province

> **" I want to build a road all the way to Pan Wang Temple, where the ancestors are enshrined. "**

The Yao

In my native Minnesota, the land of the Vikings, I am an ethnic minority and not considered a "real Minnesotan." But in China, I am part of the overwhelming majority. I am Han. As white-ness in America has defined American-ness, Han-ness continues to define Chinese-ness. Fifty-five official ethnic minorities promoted by the government give evidence of a multicultural, multiethnic China. They are revered, exoticized, or marginalized, depending on your point of view.

The ethnic Yao, who are related to the Hmong, are popular photographic subjects, with much of their economy dependent on tourism. (Guixing, from the Lianzhou Camera Association, who has photo-

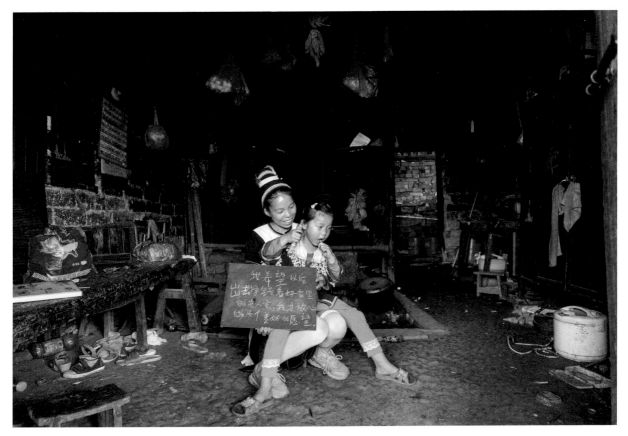

Youling Village, Guangdong Province

❝ I want to go out to make money so I can take good care of the elders at home. Then I can feel relieved. Make a good wish. ❞

graphed them extensively, was my guide.) Known as the "mountain people," they live in small groups scattered throughout China. According to one tourism website: "Yao people are very versatile, productive and intelligent, who are renowned for assorted festivals such as Panwang Festival, extravagant attires, marvelous crafts, exotic love and marriage customs, diversified singing and dancing as well as the time-honored herb Spa with outstanding medical properties."

Many in this village have left to find work in cities. The woman holding the chalkboard said her husband was working in a factory in Dongguan, and she was hoping to join him soon.

Peking opera dancer, Roseville, Minnesota

Girl wearing a Mickey Mouse shirt, Youling Village, China

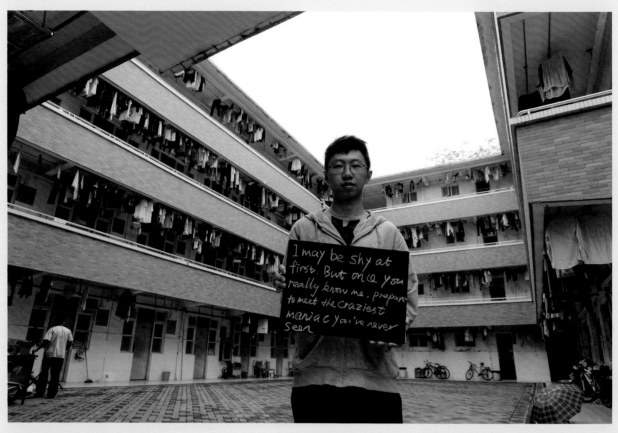

Dormitories, Guangzhou, China

I PHOTOGRAPHED STEVEN ZHANG Han, my interpreter, at Guangdong University of Foreign Studies, where he was enrolled. I had asked a relative who owned a restaurant in Guangzhou to assist in finding an interpreter. He asked a friend who asked a friend, and finally Steven was recommended. I was very fortunate. Not only was he an excellent interpreter—he had won first prize at a national English writing contest in Beijing—but he also became a collaborator and a friend.

After a couple of days, when we had become comfortable with each other, he admitted that when he was initially asked if he would travel around the countryside with an American, he became very worried. He voiced his fear to his classmates, and they all agreed he should not do it. His fear? That I was going to steal his liver. Apparently, a criminal case was in the news just a few days before I came to China: a reporter's liver was snatched while he was sleeping in a hotel. Steven was told that we might have to spend a night together in a hotel. Also, he added, "When we met you looked more Japanese than Chinese!" We had a good laugh about all of that.

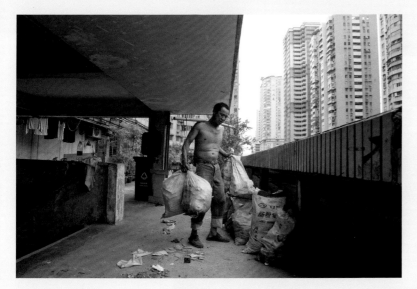

Guangzhou, China

Steven Zhang Han's comments:

When we asked this worker whether we could take some photos of him, he was a bit reluctant because he was in such a bedraggled condition and sweating profusely. "Taking a photo? For me? Am I handsome enough to take a photo?" he asked. After we explained our intention, he was very cooperative and became more confident.

He is from a backward village in Hunan Province, a province bordering Guangdong in the north. He is a married man with a child who is also a migrant worker living and working in Guangzhou. The backbreaking working condition is a stark contrast to the swanky buildings and shops on Yuexiu Hill, outside the place where he works, where inches away stands the eerily giant *Five Rams* sculpture.

HE HAD BEEN CARRYING HEAVY bags of bricks, balanced on a pole, down several flights of stairs in a building undergoing construction. By the time we arrived, around noon, he said he had already done this thirty times. When I photographed him straining to pick up his load and carefully walk down the stairs, the pole snapped in half from the weight. He just laughed and grabbed another pole.

" When I was a boy, I dreamed nothing but to fill my stomach with delicious food and buy new clothes in Chinese New Year. Now, I want to improve my living conditions. "

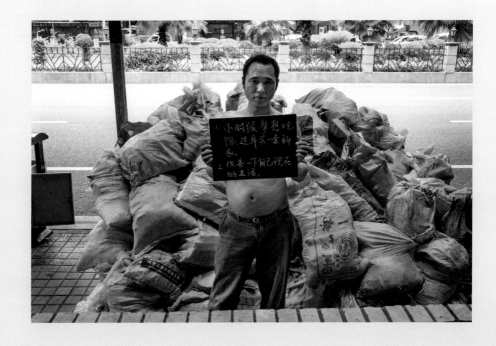

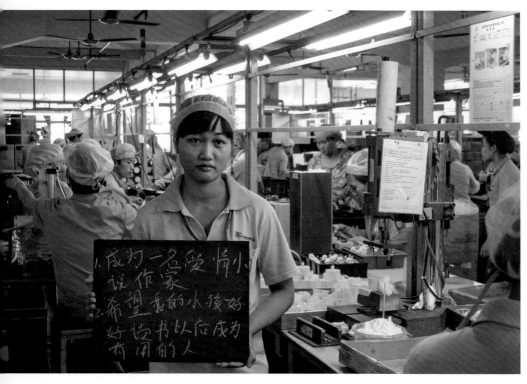

> **❝** I wanted to be a writer of romantic novels. Now I want my child to receive the best education and become a useful person in the future. **❞**

Toy factory, Dongguan, China

> **❝** My wish was to be a driver {chauffeur}. I still want that now. **❞**

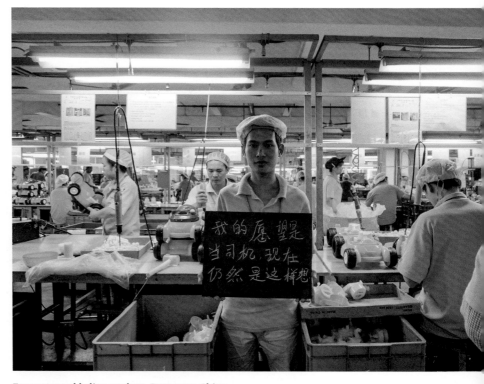

Toy car assembly line workers, Dongguan, China

A photographic master

(*Following spread*) For millions of migrants throughout China, the hope for a better life was to be found in Dongguan, a city of ten thousand factories that produced sixty thousand types of products, from shoelaces to computer parts. They had left their villages, and all they knew, to become workers in a sprawling boomtown referred to as the "world's factory." My goal was to photograph inside a factory, but I was told that it would be difficult to get permission. Then the US consulate heard of a photographer, Zhan You Bing, a migrant from a rural village in Hubei Province, who could possibly help me gain entrance to a factory.

Zhan's eye was incredibly fast. At our initial meeting, he wanted to see my photos. I cycled through them on my laptop, pausing for several seconds on each. He motioned for me to go faster, faster. After he saw a hundred photos in less than a minute, he smiled and said, "Very good!" Then he showed me his photos at the same speed. I asked him to slow down. What I saw astounded and humbled me. If it had been a kung fu movie, this is the scene where I would bow down in surrender and say: "Master."

For many years Zhan worked as a security guard in factories and hotels in Dongguan City, sending money home to his parents, wife, and son in Hubei. In 2006, working as an insider, Zhan You Bing began documenting fellow workers on and off the job. Over the past decade, he has shot more than 400,000 digital images, comprising the largest visual portrait of Chinese factory workers that exists.

At the time we met, he was juggling ten other projects besides factory workers, taking a thousand photographs a day—and working in a library to support himself. One of the projects was photographing a three-block, tree-lined pedestrian path every day for several years, which is where we took each other's photos. He reminded me of my teacher, Garry Winogrand, the master of the street photograph, whom I tried to emulate before settling into my own way of photographic seeing. And like Winogrand, Zhan often took photos of people in public without them knowing it, something I rarely do. I asked if it was easier to sneak taking photos in China, and he said that Chinese probably have less of a problem with it, but he was confident he could do it in New York.

He had studied the work of many American photographers, and it was his dream to show his work in the States. The following year, I introduced his photographs to Patricia Briggs, the curator of the Weeks Gallery at Jamestown Community College in New York, and in 2016 she presented the first exhibition of Zhan You Bing's works in the United States: "Made in China" (p. 84).

Zhan, Dongguan, China

Wing, Dongguan, China

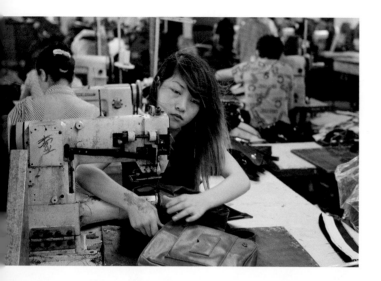

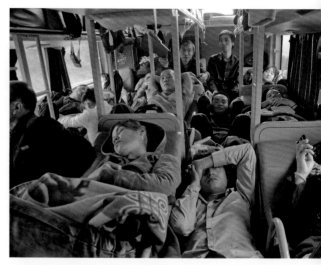

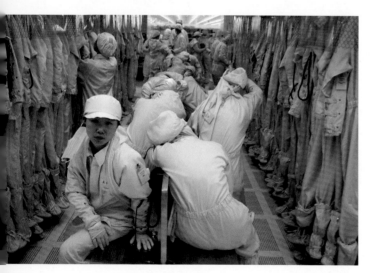

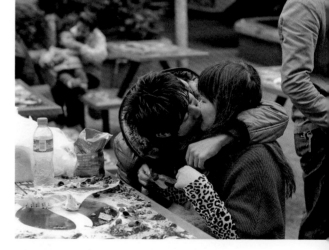

Photographs by Zhan You Bing

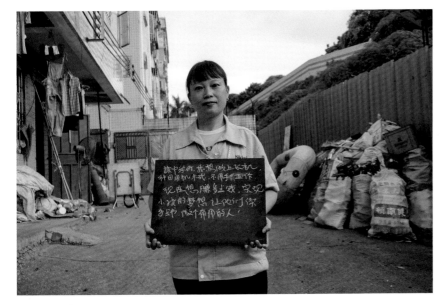

Factory worker, Dongguan

" In middle school, I wanted to use the airplane and machines to farm the field, not with hands. Now, I want to make enough money, make my children's dream come true, have them be more educated, so they can be useful. **"**

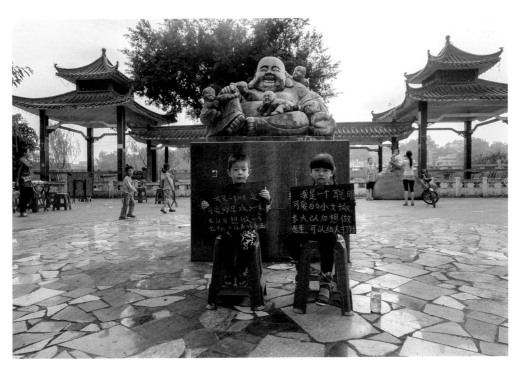

Lianzhou, China

" I am a cute boy, when I grow up, I want to be a teacher, so I can become a leader to the kids. **"**

" I'm a cute and smart girl. I want to be a doctor so that I can stick needles into people. **"**

Cheerful toy factory, Dongguan, China

I CONCEIVED THE IDEA of wearing the clothes of Chinese men whose lives I could've had on my first trip to China in 2010, while walking around Beijing and seeing guards in front of entrances and buildings everywhere, standing still and emotionless, like statues. What would that be like, I thought?

Zhan You Bing was able to get me access to photo-graph at this toy factory because he had himself photographed here many times and knew the managers well. With Zhan accompanying me we approached this guard and asked if I could wear his clothes, and he readily agreed.

He had served in the Chinese military and was stationed in Tibet before working at this factory.

Cheerful toy factory, Dongguan, China

I missed serving for my country in Vietnam by one year, as the military draft ended in 1973 when I was seventeen, which gave me great relief as I prepared for college life. However, my brother Ying, who worked sixty hours a week at the family restaurant when he was seventeen, attended college for only two semesters before dropping out to enlist in the army, serving for two years in Korea. His goal was to be a doctor, and the GI Bill would help him pay for a college education. He ended up owning a successful Chinese restaurant instead.

Toy factory, Dongguan, China

MOST OF THE WORLD'S TOYS are made in China—by workers who can't afford them. The official job title of the man on the phone is "Vice Manager of Injection Molding Department." Above everyone's blue shirt pocket, embroidered in English, is the word "CHEERFUL."

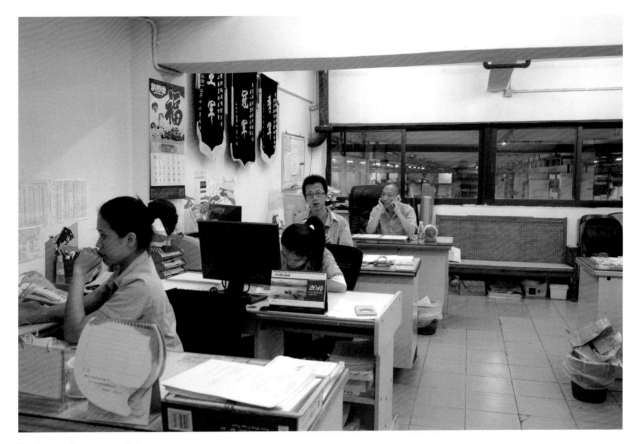

Toy factory, Dongguan, China

I HAVE NEVER WORKED in an office or factory or had any kind of nine-to-five job. I did work behind the counter at a photo supply store in my early twenties, but I quit after a couple of weeks to become a waiter at a rib joint so I could pursue my freelance career during the day.

Lianzhou, China

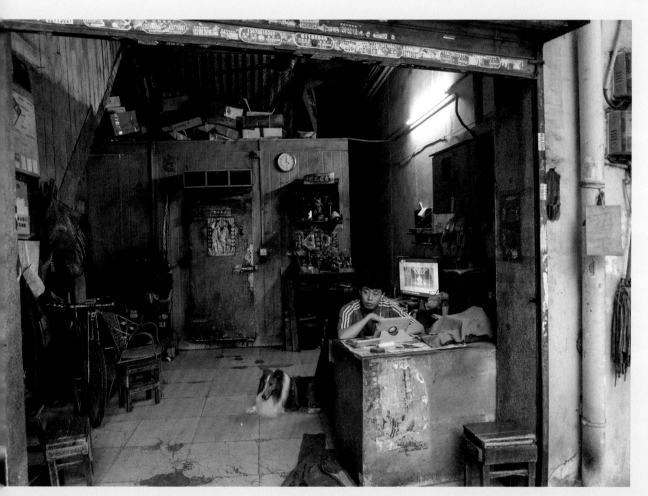

Guangzhou, China

Guangzhou Railroad Station, Guangzhou, China

He kind of looks like you

One of the largest migrations in the history of the world has been happening in China over the last forty years: people leaving small villages for the mega-urban regions in Guangdong Province, the manufacturing heartland of China. Much of the exodus is young people, the first ones in their families to leave generations of farming for a better life. They are called the "floating population." About a century earlier, another large migration left that same area to come to the United States—the second wave of Chinese immigration, of which my father was a part. He settled in Duluth at age seventeen.

My interpreter, Steven Zhang Han, suggested we photograph at the Guangzhou Railroad Station, one of the busiest stations in China; just during New Year, it moves millions of people, most of them migrants. He said, "You should try to wear the clothes of a migrant because your father was a migrant." It's a weird thing to ask anyone to wear their clothes and explain why, but to do it in such a public place, this way station of humanity, seemed an impossibility. The thought of it paralyzed me.

But then Steven pointed to a man in a blue shirt at the top of the steps. "That guy up there, he kind of looks like you."

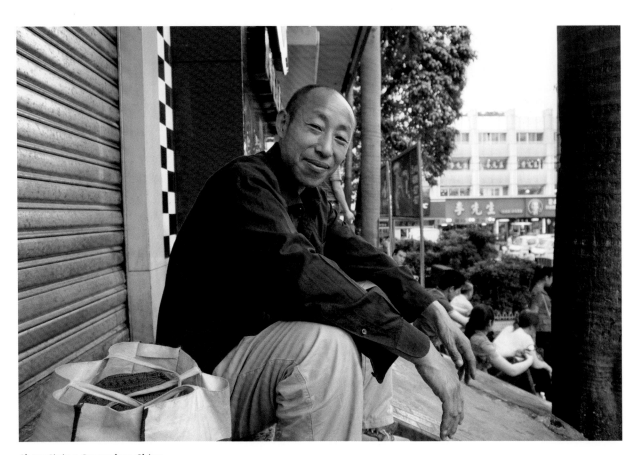

Cheng Jiping, Guangzhou, China

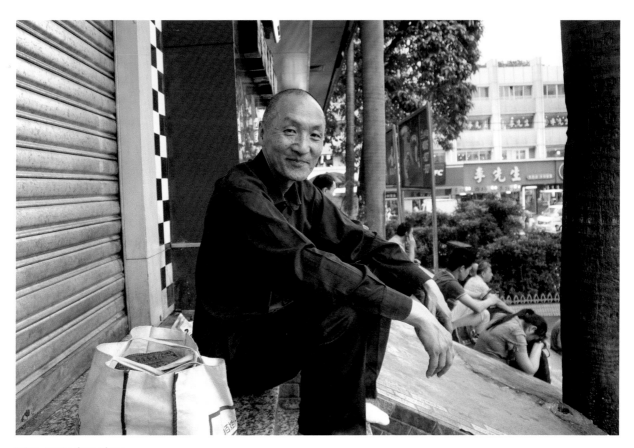

Wing, Guangzhou, China

Cheng Jiping. Signs on top of the building: To Unify the Country; Guangzhou Railway Station; To Rejuvenate the Chinese Nation.

❝ When I was a boy, I wanted to be an inventor of satellites and anything relating to space. At present, my dream is to have a good job, live a comfortable life, and get married to carry on the family name. ❞

A tiny particle of a huge power

To complicate the situation, we were accompanied by a reporter from *China Daily,* the most widely circulated English-language newspaper in China, who was doing a story on me. As the three of us walked up the stairs, I was trying not to be overcome by the absurdity of the situation. Why would this man be interested in having a complete stranger, a Chinese man from America who can't even speak Chinese, not only photograph him but also wear his clothes?

He was startled when we walked up to him and I said, "Nǐ hǎo" (hello). I asked if he spoke English and he shook his head. I then introduced myself in English and explained my project while Steven translated. This took a few minutes, and he listened intently. Then both Steven and the reporter took over and kept talking to him for what seemed quite a while. I was feeling anxious and chagrined. Steven said to be patient. I started thinking this was a bad idea and we should leave this man alone. Finally, he agreed. He was interested in my project and wanted to tell his story.

Cheng Jiping was seventeen when he left his small village in Hebei Province after his parents passed away. Now forty-seven, he had been a migrant ever since, traveling to many cities in search of work, struggling to scrape together a living. He had a girlfriend once, but she dumped him because of his poor prospects. The last few nights, he slept in the open because he couldn't afford a room. His bosses were often mean and unscrupulous. One time he worked in a Guangzhou restaurant for ten hours and got paid only 50 RMB (a bit more than eight dollars). Despite all of this, he is confident that the government will lead the workers to a well-off life. He believes in the Chinese Dream.

There is a Chinese saying that people should "eat bitter" in order to endure hardships and forge ahead. After taking the photos, I asked if he believed in eating bitter, which got him going. We spent another hour walking and chatting with him as he philosophized with pride about the difficult life of migrants. His unaffected smile, though, revealed no trace of his hard life. In my photo, I tried to match his smile and clearly came up short, although I am the one who has never really tasted bitter.

The interactive process of making this pair of photographs was perhaps the most insightful experience of my career. By blurring the boundaries between the subject and the photographer, I gained some insight and empathy for my own immigrant father through this itinerant stranger. What is it like to leave everything you've known for a foreign place—to arrive with no money, local language skills, or cultural knowledge—looking for a "better life"?

I asked Jiping if he would accept a donation (100 RMB) for being a part of this project, which he did, although he said it was not necessary. With an impish grin, he said that someday he will meet me in the United States and take another photo with me. And then, in Steven's words, "He, a tiny particle of a huge power that makes a nation really stand out in the world, disappeared among the crowds of millions of migrant workers in China as we said goodbye at dusk."

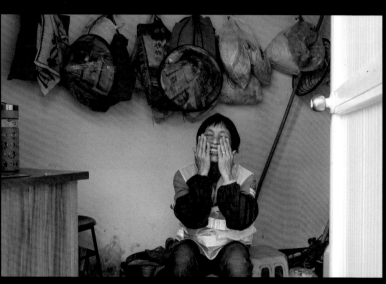

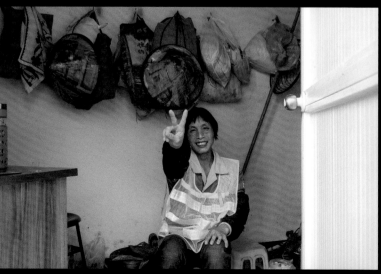

THIS WOMAN, who worked at a gas station on the road to my family's village, has never seen life beyond Toisan. When I asked if I could take her picture, she said, "Do you think I'm beautiful? I'm not beautiful enough to be displayed." When I took out my camera, she was surprised. She had never seen a camera that wasn't a phone. She is one of the "grassroots people," the majority of people in China who have little education, on whose backs the economy runs. I thought of my mother, who had only an eighth-grade education and told us more than once that she could have become a teacher because she was so smart.

Toisan, China

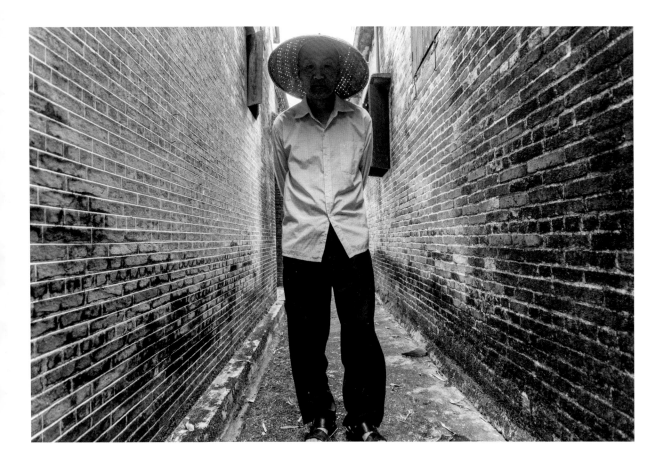

When are you going back?

The children of immigrants born in a new land face that question, whether or not it is ever answered. To go "back" to a place where you've never been—and most likely feel utterly out of place—is a curious thing. In 2014 I finally went back to my ancestral home, a village in the Toisan region so tiny it is on few maps. Of the seven houses there, only one was occupied. The other residents had left for a better life.

Our house has sat empty for more than fifty years. My father left in 1909 for Duluth. Two of my brothers left during World War II to attend an elementary school in a bigger city, then joined my father in the

early 1950s, after the Communists took over. The rest of my family followed a couple of years later. But one Huie remains in the same area, close to the ancestral village: my cousin Bo Ling, who with her husband makes a meager living farming.

My father achieved his American dream of becoming a successful restaurateur, giving his family working-class advantages and comforts unimaginable to those in the village. Bo Ling's father, however, left to find his fortune in South America and was never heard from again. Growing up fatherless and too poor to afford any schooling, Bo Ling became

rooted in the hardships of subsistence farming. My cousin has lived a life unimaginable to me. She has eaten a lot of bitter.

To get to the village, I was advised to hire a driver, as it is not an easy place to locate. The same family connections that found me my interpreter, Steven Zhang Han, suggested a trusted driver. The driver, Steven, and I made the two-hour trip from Guangzhou to the city of Taishan, where Bo Ling, her husband, Rong Gao, and two daughters-in-law waited for us on a sidewalk. They had taken a bus from the village so we could celebrate with a meal at a restaurant. There are no restaurants in or around the village.

Bo Ling was so, so happy to meet me. It was not often that relatives visited from America. My brother and his wife had come several years before, which she happily mentioned again and again, constantly wiping away her tears with a handkerchief. It was rare for her to eat in a restaurant, as her family has little money.

My family has sent money back to Bo Ling and other relatives every year since they came to Minnesota in the 1950s. This was something I was aware of, but I never gave it much thought, growing up in middle-class comfort in Duluth. For immigrants, the duty of sending back money is crucial, and not once had I ever contributed a penny of my own. It had never occurred to me. Being there and seeing how Bo Ling lived made me realize how much I've taken for granted. So it gave me a small bit of comfort to present to Bo Ling a traditional red envelope that I had filled with "lucky money."

Throughout the meal we chatted, as best we could given the translation challenges, about the family back in the States, about my trip and project, telling long-ago stories about life in the village when our families were together, and about their lives now. Bo Ling and her husband only spoke Toisanese, which Steven did not speak at all, but he did know some Cantonese, which is somewhat similar to Toisanese. Our driver, however, was fluent in Cantonese and could speak conversational Mandarin. One of the daughters-in-law spoke Toisanese and Cantonese, but her Mandarin was not that great. And so a translation train was formed. Bo Ling asked me a question in Toisanese and the daughter-in-law repeated it in Cantonese to the driver who repeated it in Mandarin to Steven who repeated it to me in English. Then I replied and the merry-go-round continued.

Afterward we drove a short distance through the rural countryside to the village, where I finally entered our house, a three-story structure made of brick and stone with decorative trim. It had artistic touches throughout, and one balcony wall was festooned with pastoral scenes and calligraphy painted directly on the weathered and cracked wood, probably when the house was built. No one remembered who the artist was. According to one of my brothers, it was the nicest house in the village.

In this house my two oldest brothers were born. During the war, the family ran from here, my mom carrying the youngest on her back as they fled through the rear door to evade the bayonets of the Japanese soldiers. Starving neighbors abandoned their children on the road near here. I thought of these and all the other family lore I heard, trickling out in bits and pieces, while growing up in our cozy brick house in Duluth. It was eerie to be there.

To wake up the spirits, my relatives ceremoniously lit strings of firecrackers and tossed them into the empty rooms and hallways, the mini-explosions reverberating off the bare walls and floors. One unexpected burst landed behind me and I jumped, letting out a shriek, making everyone laugh. More rituals followed as roasted duck, boiled chicken, and bags of candy were offered to the departed. We lit incense and burned fake paper money and joss paper for our ancestors to spend in the afterlife, and we drank out of teacups to quench their thirst. For years Bo Ling has performed these ceremonies, keeping the spirits in our house alive, as well as tending to the plot of our ancestors' graves on a nearby hillside.

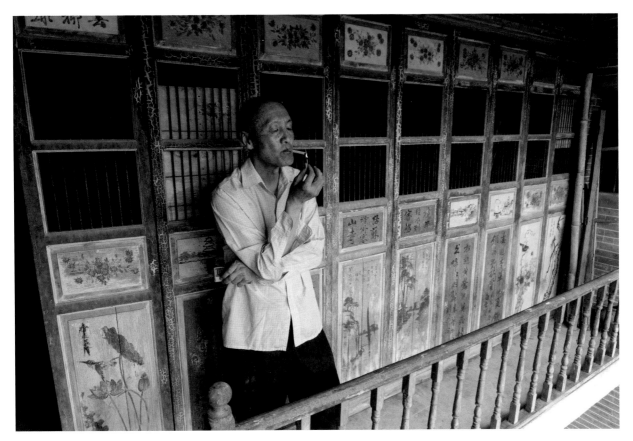

Wing in the ancestral home, Toisan, China

I SAID, "LET'S TAKE A PHOTO of me like I just got done farming." Rong Gao said, "To make it real you should be smoking, because all the men smoke." I had smoked for twenty-two years, starting when I cooked at the Chinese Lantern, my brother's restaurant in Duluth. The waitresses tipped the cooks with cartons of cigarettes, and I didn't want to be left out.

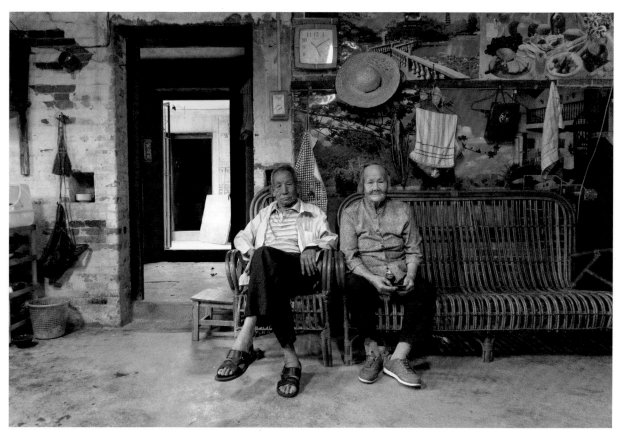

Rong Gao and Bo Ling at home

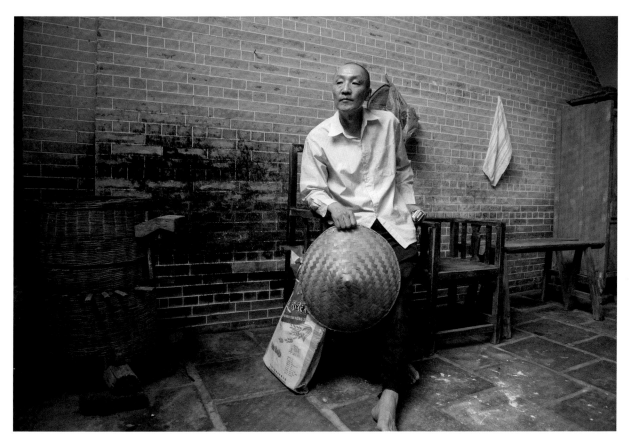

Wing in the ancestral home, Toisan, China

WITH RONG GAO'S CONSENT, I donned his clothes and gave the camera to Steven, who had become an artistic collaborator. Steven suggested places in the house for the photographs. One location was on the bench next to what my family members told me was a rice thresher. I asked Rong Gao to position me in the way he might sit. When we scrolled through the images on my digital camera, one caught my eye, and I asked what they thought. Steven said, "You look arrogant." My cousin's husband nodded in agreement. Of course, I thought. I am American.

Sometimes I am asked, "What is the best photograph you've taken?" I have a lot of stock answers. "The next one." Or, "My photos are like notes in a symphony, minor and major, but all are important." It is an impossible question. A more interesting question: "What is your best photographic experience?" My answer would be that day in Toisan, where family lore and photographic reality commingled.

CHINESE NESS ISMS #2

" I came to the United States as a young child. I learned English as my second language. I always thought I had no accent, and people used to tell me I had no accent. For decades that was what I believed. Then I worked at a call center and someone I talked to on the phone asked if I was Asian. I thought the person was psychic. Then on occasion other people on the phone asked if I was Asian. I came to the realization I must have an accent. "

—A Chinese-American woman in Minnesota

" The style in China is for girls to put on makeup to look white. In the summer we walk around with umbrellas to block the sunshine. But Chinese-Americans want to look dark. We have different ideas of beauty. "

—A young woman who was born in China and attended Stanford University in California

" I think I can tell by the way someone walks, even from a distance, whether they are Chinese from China or Chinese-American. I can't explain it. I just know. "

—A Chinese man in his forties who grew up in China and has worked with Chinese-Americans. When I repeated this to another Chinese national in his twenties, he replied, "That's the dumbest thing I've ever heard."

" Americans are so much nicer than Chinese people. They say hello, thank you, I'm sorry. Chinese are very blunt. Even though I know that Americans are often just being polite and don't really mean what they say, I prefer the American way. I find that when I speak English I am a nicer person. "

—A twenty-year-old, born and raised in Beijing, who came to Minnesota to attend Macalester College

" When I came to Champaign, a small town where everyone knows each other, every time I told people I'm from China, they would say, 'Oh, there's a Chinatown in Chicago.' I thought, 'Why would I want to go to Chinatown? I've been in the real China my whole life.' At first I avoided Chinese people because I wanted to learn English and became friends with Americans. But then I met American-born Chinese or Chinese immigrants who came to the US when they were children and have no accents. 'I've lost my Chinese character in my heart,' some of them felt. But I feel it actually stays and the stronger you deny it, the more it stays. "

—A student who was born and raised in China and attended the University of Illinois

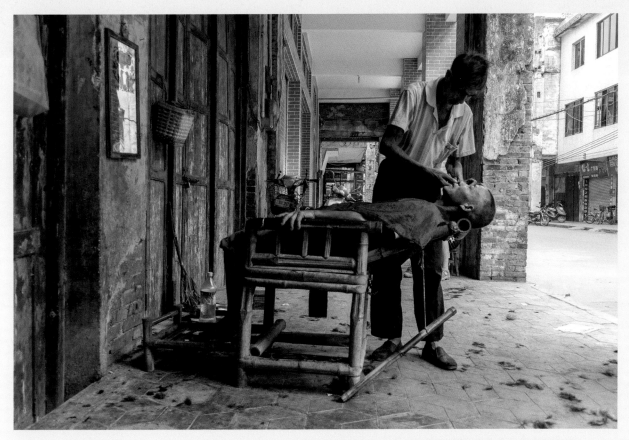

Not me, Lianzhou, China

I'VE NEVER HAD a straight-razor shave, my nose hairs trimmed, or the gunk cleaned from my ears by anyone, much less a professional. This barber, who had made the bamboo chair himself, had been plying his trade on the street for years. He was extremely fast, quite efficient, and potentially lethal. I felt that if I moved a muscle there would be blood.

Me, Lianzhou, China

Guangzhou, China

Lianzhou, China

Lianzhou, China

Youling Village, Guangdong Province

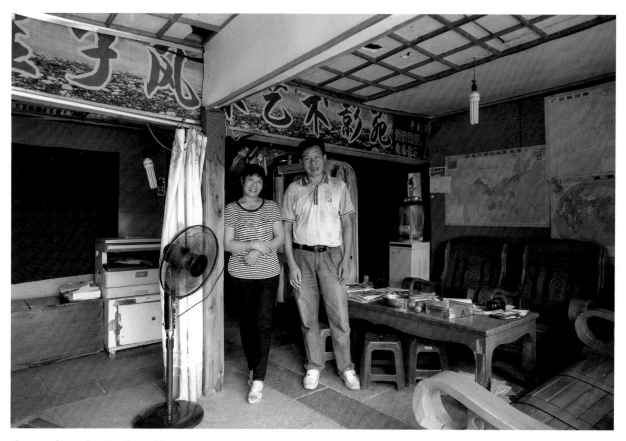

Photography studio, Lianzhou, China

Graceful in appearance

The name of the studio is Feng Cai, which means "graceful or elegant in appearance." Before this married couple opened this small photography studio, they were farmers. Most of their business is making identification portraits. The husband said that it was his dream to become a documentary photographer like me, but without an education it was not possible. He proudly showed me a film camera he used to shoot with and lamented that everything was digital now.

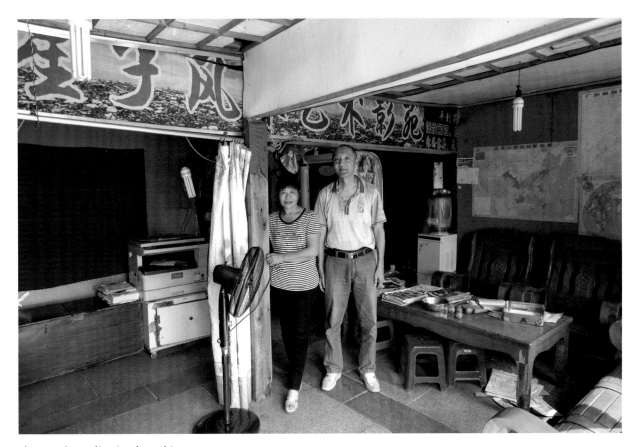

Photography studio, Lianzhou, China

IT'S A WEIRD THING to ask someone to wear his
clothes, but he was enthusiastic about doing it. I don't
think his wife was too happy about it, though.

Sexy Wing

In the studio, behind the couple, was a photo booth with several templates to choose from. I picked this one because I saw Kevin Garnett's name. I had no idea what the Chinese writing said.

A couple of years later, a University of Minnesota student from China made the translation for me. She thought it was creepy. Only teens from rural areas do this, she said, and I had picked the template for girls. However, I think this is an authentic self-portrait, as I am a random mash-up of American pop culture and my ignorance of Chinese culture.

Young girl

I want to be Superwoman {a show in China for young girls to be in a competition for singing}

I want a relationship

Ten ways for a girl to become pretty

I've finally become pretty

Non-mainstream/alternative

Clothing: Korean style

Non-mainstream clothing

Wallet that Korean cute girls love to use

The ambiguity of identity

When I was growing up, my mom would tell me, "Don't marry an American girl." Of course, she meant "white." Sometimes I would try to reason with her: "But Mom, there aren't many Chinese girls in Duluth." Or tell her, "You're an American, too." She would just laugh. The idea that she was American was ludicrous to her. I would tease her by saying I was going to marry a "lo fan" (white person), and one time I asked how much money she would give me to marry someone Chinese. She said, "A thousand dollars!" I told her it wasn't enough. I was kidding, but I think she was serious.

My mother's main purpose in life was to see her children married and to carry on the patriarchal family name, as was the goal of her mother, her mother's mother, and on and on. And to marry someone who wasn't Chinese would not have gone over well with my mom, to say the least. I did marry. But Mom did not live to see my wedding day, which caused me both sorrow and relief that she never got to meet my lo fan wife. My cultural, familial, and personal regrets are intertwined in so many ways that they are impossible to parse. For the children of immigrants, the ambiguity of identity is something we are born into.

LI CUIWEI GREW UP in the house behind her and remembers as a child not being allowed to leave the house. Her passion now is in the protection of old villages in China—working with an organization, doing research, conducting site visits, and giving lectures.

❝ When young, I wanted to get out! Now, I want my work to get out. ❞

Dongguan, China

EVEN THOUGH this man had suffered through the Cultural Revolution, he passionately praised the Communist Party and the government.

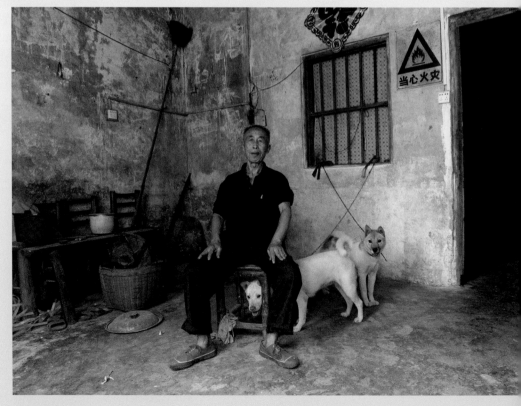

Lianzhou, China

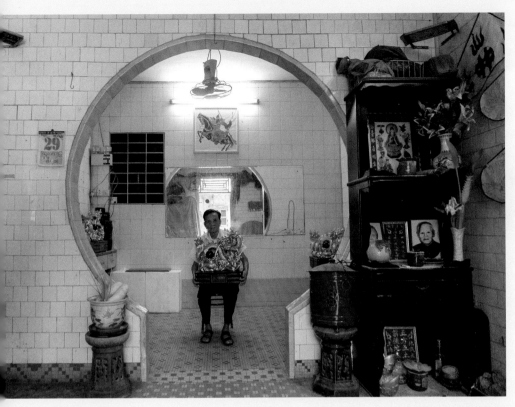

THIS MAN COLLECTS golden dragon wine containers because he was born in the Year of the Dragon.

Dongguan, China

Men's apparel store, Philadelphia, Pennsylvania

Anyone who can help me?

The writing went on for about ten paces, a private lament on a public sidewalk in broken Chinese. Steven Zhang Han had noticed it on his way to meet me. The chalk looked fresh. He said this is not something you see often. Usually people would write their stories on a wall or a big piece of paper. It was also barely legible, written with many of the wrong characters. Its author, a man, did not appear to be present, and a constant stream of shuffling pedestrians slowly erased his words. The next day they were gone.

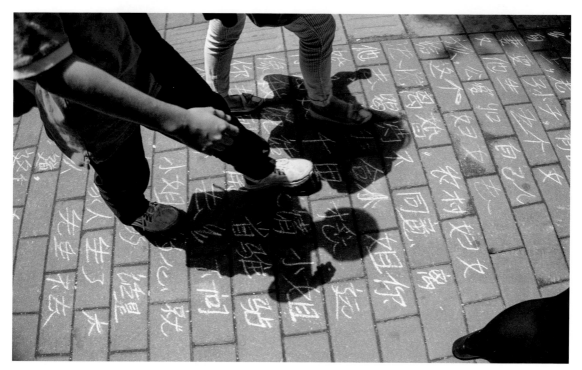

Guangzhou, China

Steven's translation:

My parents passed away very early. They had been expecting to have a grandson for many years. Unfortunately, my wife gave birth to five daughters without a single son, and this infuriates me as I feel so obliged to fulfill my parents' last wish. We decided to get divorced as a result, so we went to the court, where my wife accused me of cheating on her and hiring prostitutes. This is totally bullshit.

The newborn baby girl is bad in health condition. I can barely raise her and other girls up without my wife's help. I used to resort to the chairman of local government for help, but the wife of the chairman is unwilling to help and kicked me out of their house. Anyone who can help me? Some of you are parents yourselves and you know a baby cannot survive without milk powder. But I have no money to buy it. Some of the villagers have raised 300 yuan [less than five dollars] for me, but it cannot fix everything. I can barely witness my daughter crying out of starvation. As a parent, my biggest dream is to raise my girls up and help them build their own families. Anyone who helps me? I will never forget your generosity.

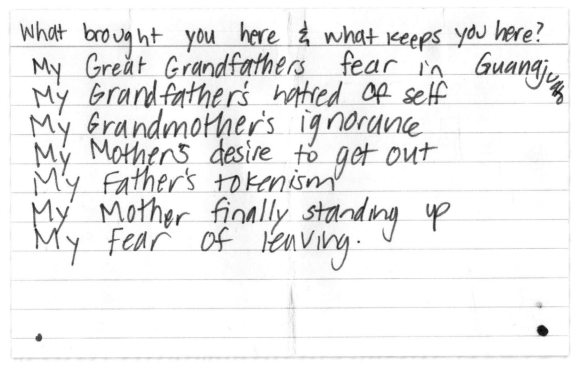

What brought you here & what keeps you here?
My Great Grandfathers fear in Guangj...
My Grandfather's hatred of self
My Grandmother's ignorance
My Mother's desire to get out
My Father's tokenism
My Mother finally standing up
My fear of leaving.

Minneapolis, Minnesota

AT A SHOWING of my Chinese-ness photos at my
Third Place Gallery, I asked people to write down their
experiences with Chinese-ness.

Yinghua Academy, Minneapolis, Minnesota

BECAUSE YOU ARE CHINESE

THE HARDEST COURSE I ever took in college (a long time ago) was the three semesters trying to learn Mandarin Chinese. The professor was from China, old school and very strict. "Raise the level of communism" and "Lenin" were some of the first words we learned. Every week we had to memorize how to write and pronounce around a dozen Chinese characters, each with a specific stroke order (average number of strokes is ten). Since Chinese is symbolic rather than phonetic like English, it's basically rote memorization. Also, Mandarin is a tonal language (four tones), so not only do you have to pronounce the character correctly, you need to use the right tone. I managed to learn around five hundred characters. To read a newspaper, you would need to know at least two thousand characters.

The tones are the hardest, but because I grew up hearing the sounds of my mother's dialect, Toisan hua (seven tones, and pronounced entirely differently from Mandarin), I felt I had the ear for tones. In all the tests and class participation I felt I did A-level work, but when I got my final grade I was surprised to receive a B. I approached the teacher and asked why. He agreed that I did A-level work, but he said I should have done better. "Why?" I asked. "Because you are Chinese," he replied.

A year later I graduated and decided to keep on learning Mandarin. I heard about a Chinese language school close to the campus for the children of Chinese immigrants. On a Saturday morning I showed up, and to my chagrin, all the students were around six years old, sitting in little chairs in a circle. Part of the day's lesson was making a kite. My cultural shame had become ludicrous. Ever since, I keep telling myself that someday I'm going to improve my Chinese. That day has yet to arrive.

I had been thinking of re-creating that humbling experience for several years, looking for the right school. These kindergartners at Yinghua Academy had been learning Mandarin for only six weeks, and the teacher was telling the students, in Chinese, to touch different parts of their bodies. I had no idea what she was saying.

Speaking Chinese makes me feel different from those around me, and helps me think more about other cultures and their differences.

说中文让我觉得自己跟的人是不一样的，也让我想到别人的文化。

Yinghua Academy, Minneapolis, Minnesota

I'm sad and happy about learning Chinese because people in China are impressed if an American knows chinese, but Americans are surprised if you don't know english.

我学校伤心和开心，因为中国人会很开心如果美国人味道中

I have better manners

Yinghua Academy, one of the top Chinese-immersion schools in the country and the only full-immersion Mandarin Chinese K-8 school in Minneapolis, has an ethnically diverse student body, especially in the lower grades, where few are of Chinese descent. I did a Chalk Talk with the eighth-grade students. The question: How does learning and speaking Chinese affect you?

Makes me feel lucky to be able to speak another language and show off my amazingness.

It makes me realize how other people live and their point of view on the world.

Learning Chinese has helped me learn what my culture is like and how I could have lived if I had never been adopted and brought to America.

I feel like I've kind of absorbed Chinese values and now I think I respect older people and my family more than "normal" children do.

Sometimes I'll talk in Chinese with my friends so my parents can't understand us.

The biggest impact on my life is it changes the way I see the US and the rest of the world and how they are connected. I feel like speaking Chinese has made me a more open-minded and inclusive person.

It always surprises them that we can speak Chinese.

Every time my family and I go out to eat at a Chinese restaurant, my mom will always try to bribe my sister and I to speak Chinese. I always say no but my sister replies with an eager yes.

Keeps my dad happy!

I learned a lot about cultural diversity and the gloriousness that is the world and how all the different parts can come together to make something beautiful. When I hear about racism in the world, it always makes me so exasperated that people could be so . . . uncultured.

Even though I may not look Chinese, its culture is deeply imbedded into my life.

It makes me feel special that I'm the only Kazakh Chinese speaker in this school and maybe even in Minnesota.

I get to learn the native language of my siblings.

Learning Chinese is a part of my personal culture and has opened my eyes so much to the bad and good of the world.

I can go back to China & talk with them.

It allows me to feel more Chinese.

I have better manners towards teachers due to Chinese culture.

One day when I was really little my mom forgot to put a lid on my sippy-cup and I accidentally spilled it all over the table. While she was wiping it up she noticed that it was shaped like China. I actually didn't even know that China existed then. From that point on I became obsessed with everything that had anything to do with China.

Yinghua Academy

THE STUDENTS at Yinghua bring a global perspective, as a number speak the language of their families' origin, including German, Romanian, Hmong, Vietnamese, Arabic, Somali, Amharic, French, Thai, Spanish, Cantonese, and Latvian. The father of a Somali student chose the school because he felt there was a "commonality between Muslim and Confucian cultures" in how they value honesty and language.

❝ I've been in Minnesota for a year and a half, and you're the first Chinese person I've met. People here think I'm Native, Latino, Black, or Hawaiian. When I tell them I'm half Chinese and half white they're surprised, and they'll ask, 'Do you speak Chinese?' {he doesn't} and then they say, 'Everything is made in China, you know.' My mom is Chinese and has six siblings who all married white people, so all my cousins on that side are half Chinese and half white. As a kid I remember that when I was with the cousins on my mom's side I saw us all as Chinese, even though we were only half Chinese. But when I was with my dad's side of the family, where everybody's white, I saw myself as white. Then in middle school I had a friend who was Japanese whose parents grew up in Hawaii, where there's a lot of people who are half Asian and half white, and the term they use for them is *hapa*. That was the first time in my life I distinctly realized what I was: Hapa. ❞

—A man in his twenties who grew up in Oakland, California, now studying shiatsu massage

❝ Have you ever heard a song sung in Toisanese? This is a question I have asked countless of Toisan people. Sometimes they will say the reason is because their dialect is too ugly, songs sound much prettier in Mandarin. My Toisan uncle, who is eighty-five, said maybe he heard a song a long time ago, back in the fields with the water buffalo. Someday I will go back to Toisan and sit in the fields with the water buffalo and listen. ❞

—A second-generation Chinese-American who is a diversity and inclusion educator and trauma counselor

❝ When I see Chinese-Americans I kind of feel a kindness in my heart because we are all Chinese. But they don't seem to behave nice to me. I read an article that talked about how Chinese-Americans want to remove their Chinese-ness and be Americans and so they keep some distance from Chinese from China. ❞

—A young woman born in China attending the University of Pennsylvania

❝ I agree, but from a different perspective, yeah. I think in some ways Asian-Americans have internalized racism because many people in the United States are racist. There's less overt racism in, say, the Bay Area {San Francisco}, but we still experience it on a micro level, and so we subconsciously pass it on. ❞

—A young Chinese-American woman in Philadelphia, an artist, responding to the previous speaker

Harry, Chinatown, Philadelphia

Wing, Chinatown, Philadelphia

The Philadelphia Suns

Conveniently, in back of the Chinese restaurant that Harry Leong's parents owned in Chinatown was an outdoor basketball court where Harry spent much of his time—until his dad yelled out the door to get back to work. All of the eight kids (Harry is number six) worked "elbow to elbow" at the restaurant, the boys in the kitchen and the girls in the dining room. With his parents working sixteen hours a day, the rule was that as long as you put in your time at the family business, you could then pretty much do whatever you wanted. You were on your own. So at around age eight, Harry learned how to peel shrimp and dribble a basketball.

Down the block from the restaurant was a church that also had a gym. He and his siblings grew up within Holy Redeemer, whose congregation was entirely Chinese, and so it was the trinity of family, Christianity, and sports that formed him. But as a kid, it was mostly sports: baseball, hockey, football, volleyball, and Frisbee. Then when he was twelve, he joined the Philadelphia Suns, an all-Chinese basketball team in Chinatown, and competed against other Chinese and Asian teams locally, along the East Coast, and in national tournaments. He was a pesky defender, and shooters loved him because he had good handles and knew how to dish.

At age twenty, he became the coach, and now, twenty years later, he leads practices five days a week in the same gym where he learned to play. In 1995 the Suns became a nonprofit, with Harry as the president, and their activities extend far beyond the court. The Suns are now a Philadelphia institution, running neighborhood cleanups, organizing numerous cultural events, and sponsoring community and educational programs. It is also one of the few basketball teams in the country that puts on an annual Chinese lion dance.

Harry's work with the Suns is all volunteer. There seems to be little difference between what he does for love and for work, though. In his real job, he is the outreach director for the Chinese Christian Church and Center in Chinatown. Most of his players are first- or second-generation Chinese immigrants whose parents either own or work in Chinese restaurants; the players have blue-collar jobs and are on their own socially. Almost all live outside of Chinatown in tough neighborhoods where there are few Chinese.

Harry thinks of the game as a tool to connect them with their Chinese-ness: hard work, sacrifice, and teamwork. His hope is that these young people will carry on this tradition to the next generation.

National Asian Basketball Tournament, Chicago, Illinois, about 1985

FOR MOST OF MY LIFE, basketball has been one of the few constants. There have not been many weeks in the last thirty years that I have not hooped. (I would have loved playing with Harry, because I love to shoot!) Like Harry, I learned to play in a church gym, the First Presbyterian in Duluth, around age ten. But all through my adolescence, I never played with anyone who looked like me. It wasn't until my mid-twenties that I started playing with an Asian group and was asked to be part of a team to represent Minnesota at a national Asian basketball tournament at the University of Illinois in Chicago.

Harry at practice, Chinatown, Philadelphia, Pennsylvania

The sight of a college gymnasium packed with Asian ballers from all over the country was surreal. It was like I was a foreign species that had finally found its way home. When I told Harry about this seminal experience and excitedly showed him this photograph I took (opposite page), to my surprise, he named every player under the basket. As it turned out, he had played in this tournament many times. The year I was there was also his first; some thirty years later, we shared a basketball court again.

Happy Land, North Philadelphia

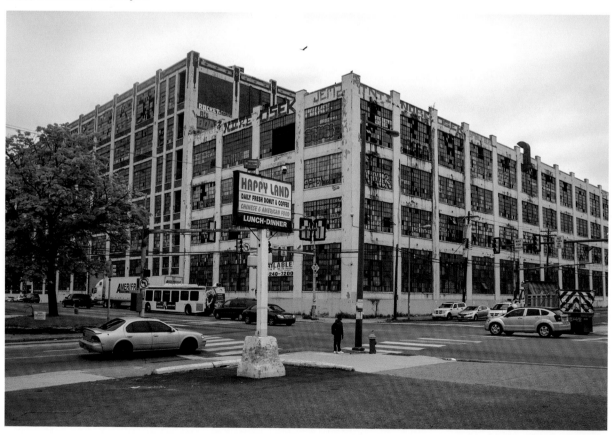

Song of the American dream

The global reach of Chinese restaurant food is un-paralleled. Chances are that in your neighborhood, whether it's Tuscany, Tuscaloosa, or Tunis, there's a place where you can get General Tso's chicken. That place can serve as a community connector or a take-out outpost. In Philadelphia, where neighbor-hoods are often racially segregated, the local Chinese restaurant is the litmus test for the kind of neigh-borhood it's in. "If it has a lobby with bulletproof glass and a security camera looking at you, it's prob-ably in North Philly," says Keir Johnston of Amber Art and Design, an artists' collective that uses art to effect social change in marginalized communities that have little or no access to art. In North Philly, where the population is around 40 percent African-American, the local Chinese restaurant often also doubles as the corner store.

Keir and fellow artist Ernel Martinez created an art installation at Asian Arts Initiative in Philadelphia, *Corner Store (Take-Out Stories)*, using the Chinese take-out/city corner store as a focal point to explore cross-cultural interactions among Philadelphia's pan-ethnic black and Asian communities. "These places fill a void and are the only crossroad of com-merce, maybe for a mile," says Keir. "They'll set up their businesses in places that are undesirable for any other business in the entire city. It's like a bomb can go off, and all of a sudden a Chinese restaurant will pop up, you know what I mean?" Adds Ernel, "They're a frontier ship. They're explorers of the world."

BEING A PIONEER comes at a cost, though, especially for the children of the owners. My basketball doppel-ganger Harry Leong says that the children, many of whom he coaches, are "literally locked in their homes and restaurants" because the parents are working too hard to take them out.

Resentment in the surrounding community can also build up against the owners. The stores may monopolize the business activity in the area since most will take EBT (electronic benefit transfer) cards. "Outside of the traditional black barber shop, there's not a lot of businesses run by people that look like the community," say Keir, who has worked ex-tensively in the North Philly neighborhoods. "You have the bodegas run by the Dominicans and the Chinese take-out stores, so in the majority of these low-income communities you have mostly two kinds of businesses. But we've always had the most respect for these entrepreneurs. At the end of the day they work their tails off and provide somewhat of an ac-commodating product to the community. Maybe it's because they're immigrants.

"Maybe it's their song of the American dream."

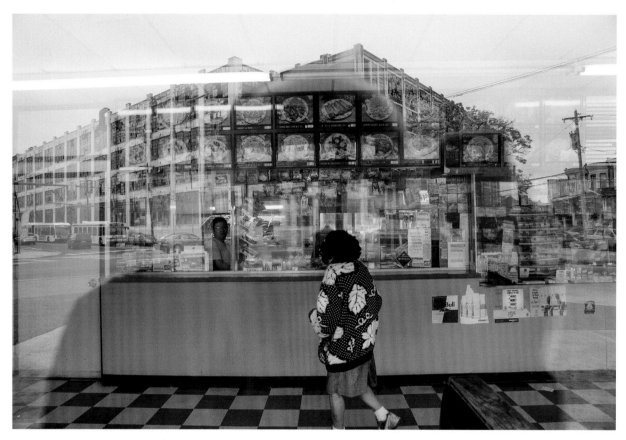

Happy Land, North Philadelphia

HAPPY LAND, A CHINESE corner store, sits in the shadow of a mammoth abandoned building. Joe, the owner, grew up in Cambodia and is part Chinese. He arrived in Illinois at age twenty-two, before settling in Philadelphia to pursue the American dream of owning his own business. Twenty-some years ago, that dream came true when he opened Happy Land next to a busy bus stop in North Philadelphia, provid-ing take-out Chinese food, donuts, and lottery tickets. (At the time I took this photograph, he wasn't serving food, but he hopes to do so in the future. In the mean-time, he still serves donuts.) The name was inspired by a vacation trip to Dutch Wonderland amusement park, ninety minutes west of Philadelphia. "I thought it was the best name I could pick out."

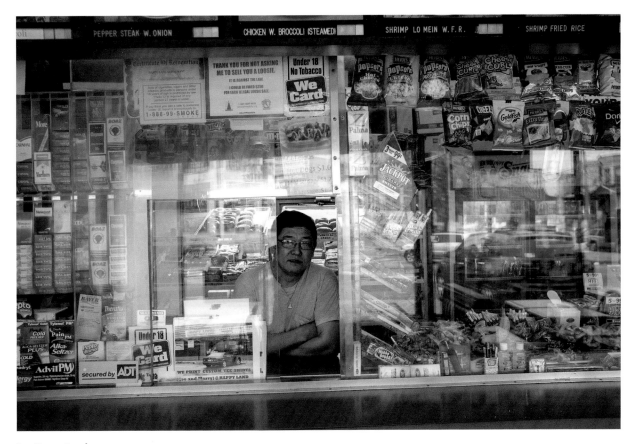

Joe, Happy Land

MARK, WHO HAS BEEN a regular customer for more than ten years, said Joe is a genuine good guy and an important part of the community. "Everybody knows him and there really is no bad word about Joe. The place would not be the same without Joe. A lot of people love Joe around here, and pretty much we hope he stays forever." There's another reason for Mark's loyalty: "Me and my coworkers have had a few winners at Happy Land. So when we hit, we go back to the same spot. So not only is Joe a good guy, he's also good luck."

Mark, Happy Land

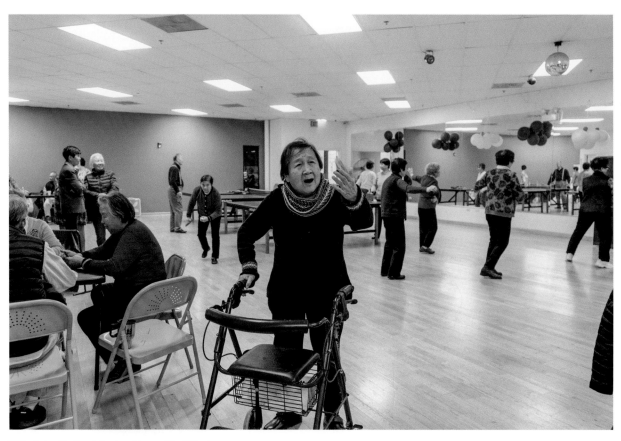

Xilin Asian Cultural Center, Naperville, Illinois

ZHANG BEGAN SINGING traditional Chinese opera when she was nine years old and enjoyed a long career in China before coming to the United States in 1990 to help raise her grandchildren. She gave an impromptu performance for me, singing a song as a female character and then as a male character, as cross-dressing is integral to Peking opera.

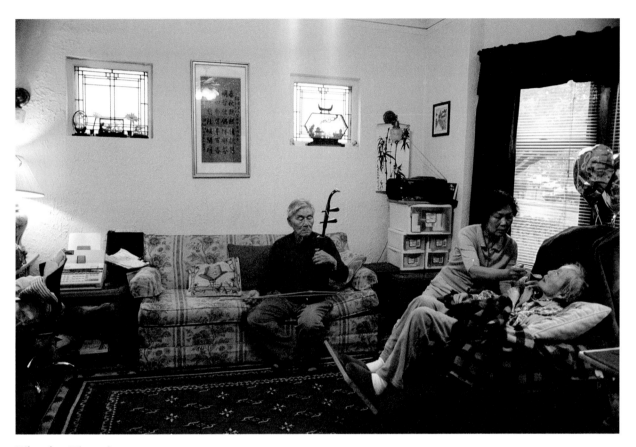

Milwaukee, Wisconsin

Love

(*Previous spread, right*) Alfred and Huifen grew up in neighboring provinces in China, separated by a mountain, not knowing of each other until the Chinese Civil War brought them together. They were among the two million refugees driven to Taiwan after the Communist Party took control of China in 1949. She ended up working as a bank teller and he as a pilot in the newly formed Republic of China. They met through an acquaintance, and soon after, he showed up at her bank during a snowstorm and offered to walk her home. They've been inseparable ever since.

In the 1970s, after Alfred retired from the air force as a major, they moved from Taiwan to Milwaukee to be with their daughter, Judy, a teacher who attended graduate school there. Huifen kept track of the family's finances, as she had a sharp mind for numbers. She never kept a telephone book, preferring to memorize the numbers. Then one day, in her sixties, she forgot how to close the mini-blinds. As her memory faded, she slept more and became depressed. "My dad tried everything," Judy says. "First the American way, and then with Chinese herbal medicines, hoping for a special cure, some magic."

It was difficult for Alfred to accept that his wife would not get better. They used to listen to Chinese opera and dance together. He taught himself to play the erhu, a two-stringed Chinese violin, so he could play love songs every day to comfort her and bring back some of the special moments they had shared. Since she has difficulty swallowing, he grinds up her medication, puts it in applesauce, and whispers sweet words while feeding her. He developed his own therapeutic routines, helping her to walk from the living room to the kitchen every six hours. But it was exhausting. Judy was able to talk her reluctant father into accepting the help of a home health-care worker. When the health worker saw how much Alfred doted on his wife, she remarked, "It seems they still are very much in love."

Judy and her husband moved into the flat above her parents to help. "My father's way is the old country way," she says. "There's a Chinese saying that when parents have been sick for a long time you won't have good children anymore. Before I would feel guilty about going places, but now I feel that I can only do my best and that I have to live my own life. We will try to keep our mom [here] as long as possible. We're concerned for Dad to take better care of himself because he spends all his time taking care of Mom.

"I think our cultural obligation is changing. Even in Taiwan, people are moving away from home to a different city and have their own lives and cannot take care of their parents. For my generation, I don't think I will be putting the same burden on my children. I will just move into a nursing home because I want them to be free from responsibility."

For Alfred, there is no other way. "I never feel angry," he says. "When I feel sad, I play music, and then I'm happy. Everybody is going to be old. It's the nature of things. I never worry about it. If you don't think about it, you'll always feel young. I always think positive thoughts."

Milwaukee, Wisconsin

REFUSING TO PUT his wife in institutional care, Alfred reconfigured the house to make it safer, padding the shower handles with foam and retrofitting her wheelchair to make her more comfortable.

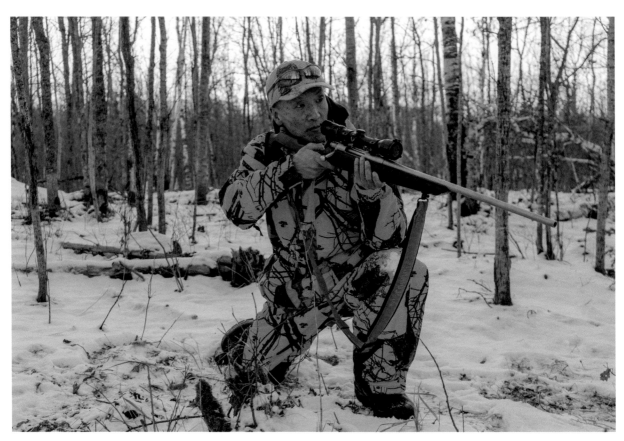

Wing, Duluth, Minnesota

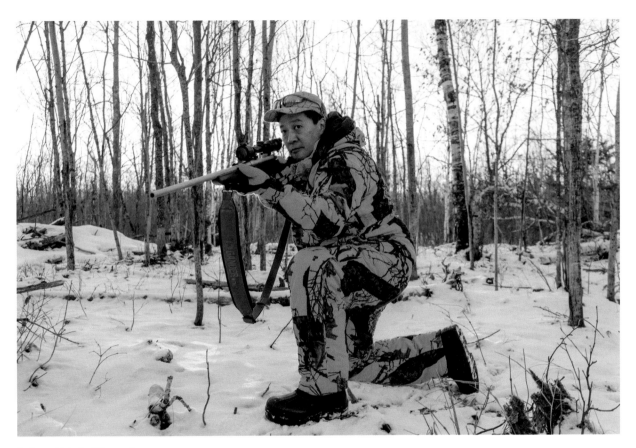

Andrew, Duluth, Minnesota

The first hunt

(*Previous spread*) For most of my life, I've lived in the land of ten thousand lakes, and I can barely swim. Never played hockey, been ice fishing, or ridden a snowmobile. I've also never killed an animal or worn camo for any occasion. And yet I dare call myself a Minnesotan. Andrew, although a transplant from the Pacific Northwest and now a Duluthian, is, at least in this last way, more a Minnesotan than I am.

The son of scholars born in China who became professors at Washington state universities, he is a cardiologist at a heart and vascular center. He was lured here after medical school by "the siren call of Garrison Keillor's *A Prairie Home Companion* . . . an audiographic version of a Norman Rockwell–like portrayal of midwestern America." He is now married to a woman who is "pure-blooded Norwegian, just as I'm pure-blooded Chinese." They have two "hapa kids,"* a son and daughter in their early twenties.

He and his wife try to instill both cultures in their children, with varying results. At meals, they use chopsticks and at the end say, "mange takk for maten," Norwegian for "many thanks for the food." Their daughter, Alexa, who joined our conversation, identifies with some aspects of both cultures but mostly just considers herself American.

One mutual trait, though, is the stoicism in both Chinese and Norwegian cultures, what the whole family laughingly refers to as "emotional constipation." Alexa remembers when she first told her Chinese grandfather that she loved him in Mandarin, which didn't go over well. "And it's kind of the same thing on my mom's side." Andrew notes, "We are by no means the only descendants of a culture that does not include many outward manifestations of affection."

Andrew grew up in the Seattle area, where the culture was very pro-nature and anti-hunting, so "shooting Bambi was forbidden." But in Duluth, about a dozen years ago, Glenn, a church friend, "casually inquired if I had any interest in accompanying him on a deer hunt." By then, having dined in "north woods–style" lodges festooned with the "heads of large mammals possessing large antlers," Andrew had become somewhat acclimated to the area's hunting culture. In an attempt to not appear unmanly to his "Packer-backer Wisconsinite" friend, he said yes.

A conversation with a classmate in Montana, a hunter, many years before had stayed with him. The hunter had asked, "Do you eat meat?" Andrew replied, "Yes, I do." To which the hunter retorted, "How do you think the meat got into its cellophane package?" Andrew's essay on that first hunt details the primal communion with nature and his thoughtfulness and preparation to place his shot safely and properly to kill the animal outright. He killed two deer that day; taking the lives of animals was something "that no one in my family on either side for at least four hundred years had ever done." He felt like he was breaking new ground, and he proudly displays the head of one of them, a ten-point buck, in his basement—next to an eight-point his son shot. When he told his mother in Seattle about it, her response was, "Why did you do that?" When he explained the logic and reasoning behind it, she said, "Well, good, then."

* Originally used as a derogatory label derived from the Hawaiian word for "half," *hapa* has been embraced as a term of pride by many whose mixed-race heritage includes Asian or Pacific Rim ancestry.

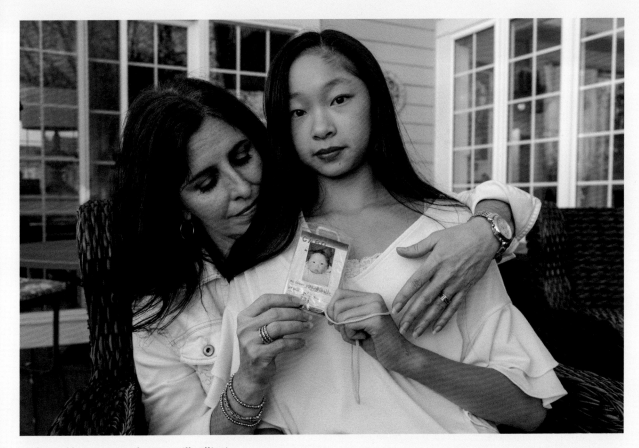

Sophia and her mom, Nicole, Naperville, Illinois

SOPHIA, NOW ELEVEN, is holding a badge with a photograph of herself as a baby. She wore this badge when she was one year and one day old, her "gotcha day," the day that she first met Nicole, shortly before she was adopted from China. When I showed Nicole the photo I took, it made her emotional and brought up a "flood of memories, hopes, intentions, and commitments, while trying to filter out the fantasies . . . to the reality of us as the daughter and the mother we have become together."

Sophia: "I like to dance because it is fun, it feels good, and I mostly feel happy when I dance. I practice about twenty-five hours a week and have performed in eleven events this past year doing eighteen different kinds of dances, including ballet, pointe, lyrical, jazz, hip-hop, and contemporary. In the future, I hope to go to college for dance and perform professionally."

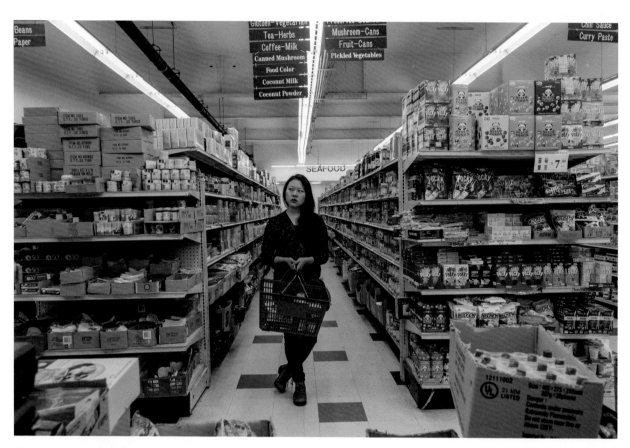

Shuang Hur Oriental Market, Minneapolis, Minnesota

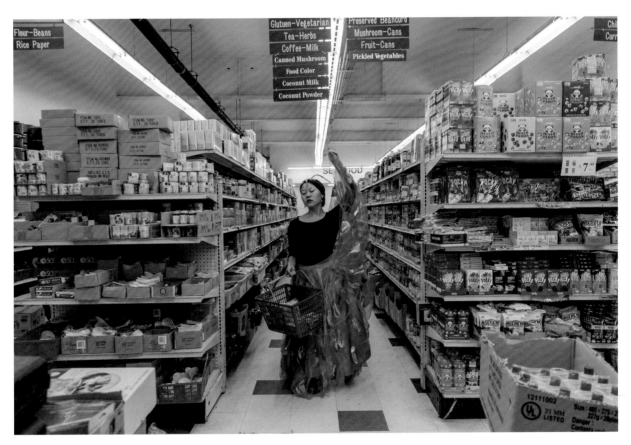

Shuang Hur Oriental Market, Minneapolis, Minnesota

"motherlanded"

(*Previous spread*) Julia, who grew up in Cleveland Heights, Ohio, has had several mother figures in her life besides the mother who raised her. The first was the owner of the Chinese restaurant where her mom would take her as a child, "an older woman with kind eyes" who always remembered her and greeted her in Chinese, "Nǐ hǎo," to which she always replied shyly with, "Hi." Another was her Chinese dance teacher, who was "super intimidating" and knew only a little English, like how to say, "One more." In that class she learned her first words in Chinese: "Thank you, Teacher" and "Teacher, goodbye."

Then there is her birth mother, of whom she has no memory: "She's like this glowing, shimmery figure that I can't really define."

When Julia was one and a half, her single mom adopted her from Ganzhou, China. She remembers pestering her mom when she was about eight, "Mom, when are we going to China? We've got to go!" When she was eleven, her mother granted her wish, and for two weeks they "did some touristy things" and visited the orphanage she came from. And then they stood in the exact spot where she was found as a baby. Someday, she decided, she would come back and find her birth mother.

In order to do that, she thought, she would need to speak Chinese fluently and really understand Chinese culture. After they got back, her mom looked for a Chinese language school, but the closest one was an hour away. So instead Julia learned the foreign languages that were taught in her school, French and Spanish. She later found a Chinese cultural school that rented out a high school on weekends, and she learned Chinese acrobatics there, but it was the traditional Chinese dance that drew her, and she took classes for ten years. The school also offered Chinese language classes, and she tried them but soon dropped out.

When she attended Macalester College in St. Paul, she still hadn't learned Chinese, and the cultural guilt ate away at her. She was more interested in Spanish and studied abroad in Argentina for six months. "And now, my Spanish is pretty good but I still haven't learned Chinese. Yeah."

But then in college her adoptee-ness and Chinese-ness became woke through the mentorship of Sun Mee Chomet, an established actor, dancer, playwright, and adoptee who received national acclaim for *How to Be a Korean Woman*, her one-woman play about her reunion with her birth mother.

Julia was inspired to create her own one-person play, titled *motherlanded*, in which she plays her different mother figures, partly as a way to understand the complexity of her relationship to these women and to China: "A mixture of nostalgia and melancholy and this shame of how Western I am, how I've been totally influenced by white-ness and American-ness. Like somehow I cheated on China by growing up in the US."

Gooey noodles

The process of creating and performing the play helped Julia to explore her Chinese adoptee identity and open up a dialogue with her mom. She had never asked about how she was adopted and raised or about her mother's cultural background beyond being white.

Her identity conflict was apparent on campus because it was "harder for me to click with people from China than it was to click with other international students. I was kind of afraid of them and their Chinese-ness." She realized that she never learned Chinese partly because she was "scared to go back to China."

So for Julia now, going to the Asian grocery store is sort of like going to China. "When I walk in, I'm never really sure what I'm looking for. And the smell totally brings me back to when I visited China. Except in China it was a dead giveaway that I was adopted because I'm walking around with this white woman. But here by myself in this grocery store I could be Chinese Chinese." She imagines that she can read the labels and that people there assume she speaks Chinese.

"It's almost like playing dress-up. I can pretend to be somebody I'm not." (In the photo on the right, Julia is wearing the peacock dress she ordered from China and wore in her play.) "But then I'm worried that I'm going to totally give it away when I go up and pay." And so she wanders through the aisles and buys whatever appeals, brings it home and experiments. "There are hundreds of options in the rice noodle aisle, and I never know which one to choose. Last week I picked one and it was too gooey. It wasn't good. Maybe I cooked it wrong. But it's okay, because it's all Chinese."

The Paper Dreams of Harry Chin, History Theatre, St. Paul, Minnesota

PAPER SONS AND DAUGHTERS

WHEN I STARTED SCHOOL, all my fellow students knew me—and I knew myself—as Wing Young Gee. In third grade, I started to notice that my father was becoming upset and worried. I had never seen him like that. It wasn't until several years later that I learned that Gee was not our real family name; it was a false paper name that my father used to enter the United States. My father was a "paper son," a victim of the Chinese Exclusion Act of 1882, the first law in American history to prevent a specific ethnic group from immigrating to the United States.

My father was anxious because he was preparing to enter the Chinese Confession Program, created by the Immigration and Naturalization Service, which offered legalized status in exchange for confession of illegal entry into the country. But there were risks. The program resulted in nearly fourteen thousand confessions. The majority who confessed were granted a path to citizenship, although many were deported. Our family was one of the lucky ones, and we were granted amnesty. This status allowed us to change back to our real name, Huie, when I was in middle school.

In 2017 the History Theatre in St. Paul produced an important play called *The Paper Dreams of Harry Chin*, which evoked the stigma, fear, and secrecy of being illegal immigrants and its effects on those closest to them. Playwright Jessica Huang dramatized the true story of a paper son who settled in Waseca, Minnesota. I was commissioned by the theater to photograph and collect the stories of descendants of families affected by the Chinese Exclusion Act. I had all the people I photographed hold photos from their family archives. The pictures I took were exhibited, mural sized, on the outside walls of the History Theatre, and in the lobby was an interactive display where audience members were invited to add their ancestral photos and stories, transforming the exhibition into a shrine of remembrance. As part of the exhibit, I wrote:

> Those who came before us traversed borders, often hiding their true selves, even from those who loved them most, leaving a legacy of unknowing. What did our ancestors endure? How much are we a product of that endurance? What do we know of their struggle? Maybe they would have told us more—if only we had asked. If only we had wanted to know more. Our memories are shaped by the images they left. Precious family photographs are, in essence, paper dreams.

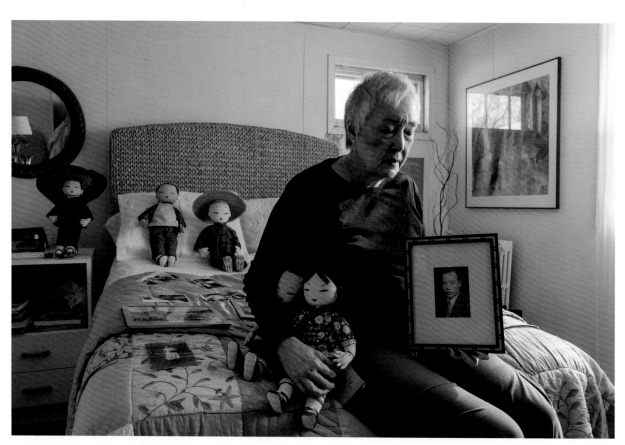

Sheila Chin Morris, Waseca, Minnesota

Freedom is like a current of water

Sheila Chin Morris, the co-executive director of the Waseca County Historical Society, is holding a photograph of her father, who passed away in 2013. Known by his paper name, Harry Chin, he was born Liang Cheung You and immigrated from China to St. Paul in 1940, leaving behind his wife and infant daughter, as well as his mother, brother, and sister. He worked in a Chinese restaurant, earning a dollar a day; during World War II, after two months of schooling, he became a sheet metal mechanic for Northwest Airlines, earning a hundred dollars a week.

The war stopped all communications with his family in China, and the difficulty continued with the Chinese Civil War and the establishment of a Communist government. He married a woman from Winnebago, Minnesota, who was working as a waitress in a Chinese restaurant, and they started a family. But in 1955, when the "confession" program was implemented, Harry's American family finally learned of his paper son identity. And a few years later, he re-established contact with his family in China. With much work through several years, Harry reconciled with both families. In the 1980s, when travel and immigration again became possible, he brought his last remaining family member from China to the United States.

Sheila Chin Morris: "My dad loved apple pies. John Wayne was his absolute hero because he believed that John Wayne actually did everything that he did in the movies. In the movie *Flying Tigers,* John Wayne helped the Chinese people fight the Japanese. [Dad] believed he really did that. So on his last days, that was the movie we watched over and over again.

"When we buried my dad, there were things I felt I had to put in the casket with him, because his needs were so small, so simple. The little lap blanket that had the classic picture of John Wayne that my stepson Eric gave him, his Vikings hat because he never gave up on the Vikings, a roll of masking tape because he thought he could fix anything with masking tape, his TV remote. Then there was the little rice dish that his best friend Jack Wong had given him and the third stone that came from his mother's grave in the village in Toisan that we put right in his hand so that he would always have China with him. I put a twenty-dollar bill in his pants pocket because he was never without cash.

"My sister gave him this little pink and red pamphlet that said 'Passport to Heaven' in Chinese because she was evangelical. Then there was the cross my dad had cut from construction paper that he had in his room at the nursing home. On one side it said, 'I love you,' and on the other side, 'You love me.' So I took those three pieces of paper and hid them on the inside of his casket, so we know that he knows Jesus. And that's how we buried him.

"This play by Jessica Huang I feel is an important historical education. America is a nation of immigrants, and the quest for survival and freedom is like a current of water: it finds a way."

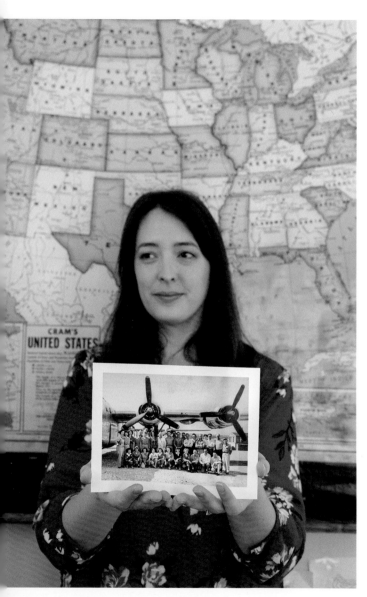

Erin Becka, Duluth, Minnesota

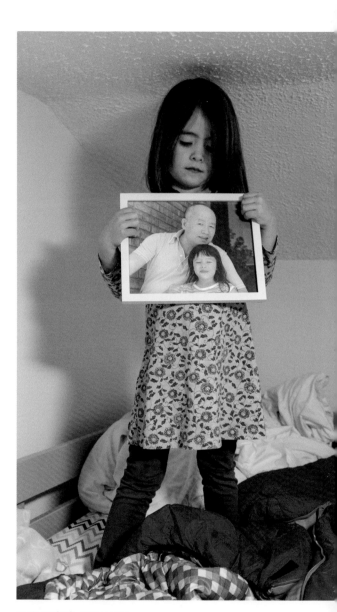

Berit, Duluth, Minnesota

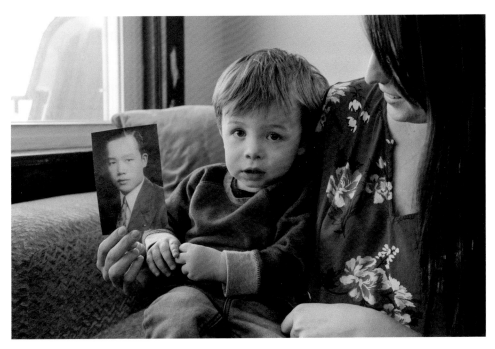

Charlie and Erin, Duluth, Minnesota

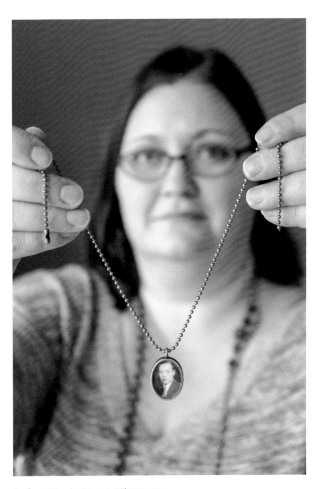

Andrea Morris, Otsego, Minnesota

You could see Grandpa Harry in his face

(*Previous spread, left*) Erin Becka, the daughter of Sheila Chin Morris, is holding a photograph of Harry and his fellow employees who helped build airplanes for Northwest Airlines at the end of World War II. When she was a kid, she would come up from Waseca and visit with Grandpa Harry in Minneapolis when he worked at the Nankin Café. Now Erin and her husband, Matt, live in Duluth with their children, Berit, age three, and Charlie, who is almost two. In the photo, Berit is holding a photograph of Erin with Great-grandpa Harry.

Erin: "Charlie [who is one-eighth Chinese] was born with light hair with blue eyes, but after six or eight months we started to notice that at certain angles and expressions, like his smile, you could see Grandpa Harry in his face. His grandfather Paul has blue eyes, so we were expecting him to look like that side of the family, but then there were angles where we could really see my mom and Grandpa Harry in his features.

"The way I grew up was different than my mom. She was definitely discriminated against. But in my generation people were nice and accepting of different races. I remember saying that I'm Chinese and I was proud of it, which I am. The only times I think about my Chinese-ness is when someone asks me what my nationality or heritage is. They don't guess that I'm Chinese, but that's really the only time that it comes up or it affects my life is when somebody asks me. Mostly they assume I'm Native up here. For my children, I will offer the information about their Chinese heritage if they're interested. If not, I'm not going to force them to be interested. It's an individual choice. We're fortunate because of all the research my family has done. My father is into his genealogy, and my mother works at the Waseca County Historical Society. I know that that information is there and will be available for us. I feel in my own experience we've gotten past the assumption that someone is different—times are different than when my mother grew up."

My grandpa is Chinese

(*Previous spread, right*) Andrea, the stepdaughter of Sheila Chin Morris, is holding a photograph of her grandfather, Harry Chin.

Andrea: "When I was growing up, I would tell other kids that my grandpa was Chinese. It confused people. They didn't believe me. After Grandpa passed away, Sheila gave me this photo pendant. I've always loved this picture of Grandpa. He looks like a baby; he looks so young.

"When I wear it I get weird reactions when I tell people it's my grandpa. It's like they don't really know what to say, or they try to come up with a very diplomatic and politically correct way to talk about it. So I just tell them, 'Well, he's not my blood-grandpa, but he's been my grandpa as long as I can remember.' It's a thing I love to tell people because I think it really speaks how family does not necessarily have to be blood, which is important for people to learn and to know about.

"As a teacher, I decided to use it in the classroom. When my teenage students make some racial remarks, I'll tell them that my grandpa was Chinese. It kind of blows them away. A lot of them are speechless. I say, 'When you don't know the other person's story, don't make assumptions.' My blood heritage is mostly Swedish and Danish, with a little Welsh and miscellaneous European thrown in. So I use it as a learning tool. Hopefully it works!"

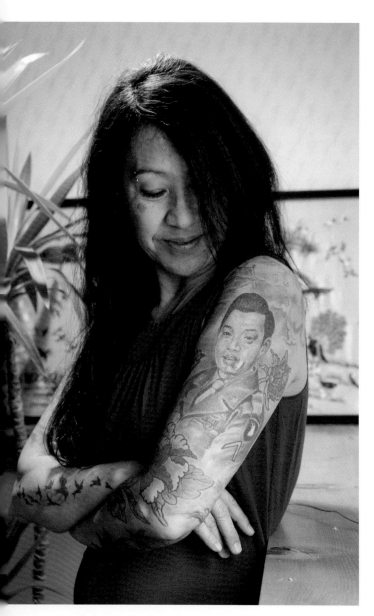

Gloria Berg, Maple Grove, Minnesota

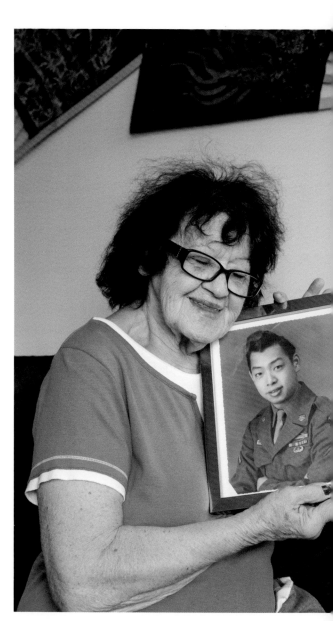

Lucille Moy, Maple Grove, Minnesota

He was so extremely quiet

Fred Moy, Harry Chin's younger brother, immigrated in 1937, at age eleven, also passing the test as a paper son. He served in World War II with the famous 101st Airborne Division, the Screaming Eagles. He cooked in Chinese restaurants in Minneapolis, where he met his wife, Lucille. Together they owned and ran Hoe Kow Chow Mein Restaurant in north Minneapolis for forty years. Their two children are Randy Moy and Gloria Berg. Fred passed away in 2013, the same year as his brother Harry.

Gloria Berg: "I got the tattoo in 2013 as a memorial to the passing of my father. It's taken from his army photo where he's wearing his Screaming Eagle patch on his uniform. He was in the 101st Airborne. I found out little bits and pieces at a time, from memories that my mom had had, little bits and pieces that I was able to get Dad to talk about, and lately within the last several years I'm connecting more with my cousin Sheila.

"About a year before my father passed away, my husband, Mike, was in a bookstore and noticed a book called *Chinese in Minnesota*. He browsed through it and saw a photo of Uncle Harry in it. He brought it home and asked if I knew about this, which I didn't. My cousin Sheila had given an interview about her father, Harry Chin, who was a paper son. So I contacted her and found out a lot about the history of my father. There's so much we learned in the year before he died. It gives me a greater feeling of pride, knowing that I'm here because of his struggles."

LUCILLE MOY IS HOLDING a photograph of her husband, Fred Moy: "We met on a blind date! I was working downtown in Minneapolis at the Kinshu, a Chinese restaurant. One of the girls that I worked with set up a date for Fred and I. It went really well! We were married for fifty-five years.

"He was so extremely quiet. You could sit for hours and hours and hours and not talk. Like I said, he didn't really talk too much about his family or too much of anything. I had no idea how old he was. I never knew who was related to whom. Because he was a paper son there was a secrecy that seeped into everything.

"When Fred and I got married, that was a rare, rare thing. There weren't many interracial marriages back then, but I never paid any attention to it. That he was Chinese and born in Canton, China, and was much, much older than me, it never crossed my mind because it didn't make any difference! I have all kinds of good memories. I was really proud to be married to Fred.

"For Gloria and Randy, it's a real honor to be half Chinese and half something else. My father was full-blooded Irish, my mom's father was born over in Sweden, and my great-grandmother was full-blooded Indian. We are quite a mix."

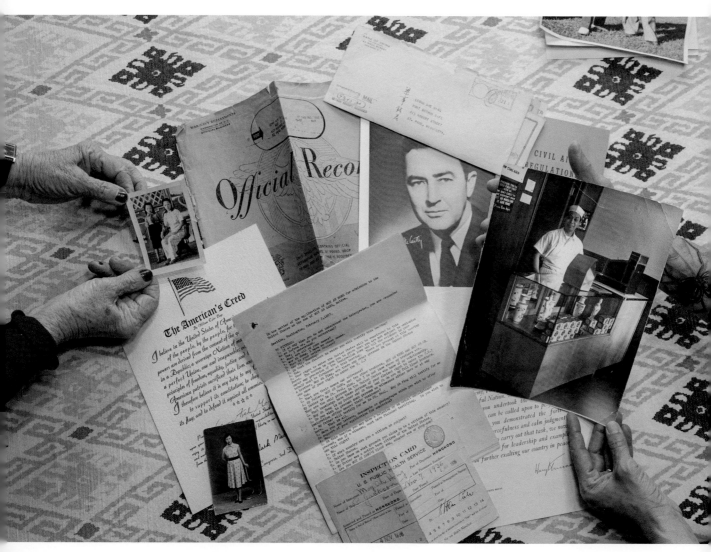

The papers of Fred Moy, Maple Grove, Minnesota

GLORIA BERG: "Lucille has kept a box of Fred's memorabilia, some eighty years old, locked away in a safe. Much of it contains items he carried with him from China, such as negatives and photographs that could fit in your palm. One depicts him as a child playing the violin."

Also contained are various items that reflect his life in the United States and his military service in World War II: personal letters, snapshots of family and friends, newspaper clippings, official government proclamations and testaments. And, amazingly, on yellowed paper, the typed testimony of his interrogation by immigration officials in 1937 about who Fred Moy claimed to be. At the tender age of eleven he had memorized the facts of his paper existence, passed the test, and claimed citizenship.

The box that encapsulated Fred's real and paper life had been locked away for years, seldom glimpsed. It wasn't until I photographed Lucille and Gloria on February 14 that they fully examined it, spilling its contents onto the kitchen table.

Gloria: "It's a snapshot of personal treasures of what it took to come into this country. My father was a paper son. He had to assume somebody's identity and memorize the life of somebody [he knew] nothing about. And then to be questioned on it, interviewed about it, and one wrong answer, one wrong word sends you right back to your country—and you lose out! That's what happened to my father. I wonder how much of my being born here was a factor to [their] giving my father amnesty. History is coming around."

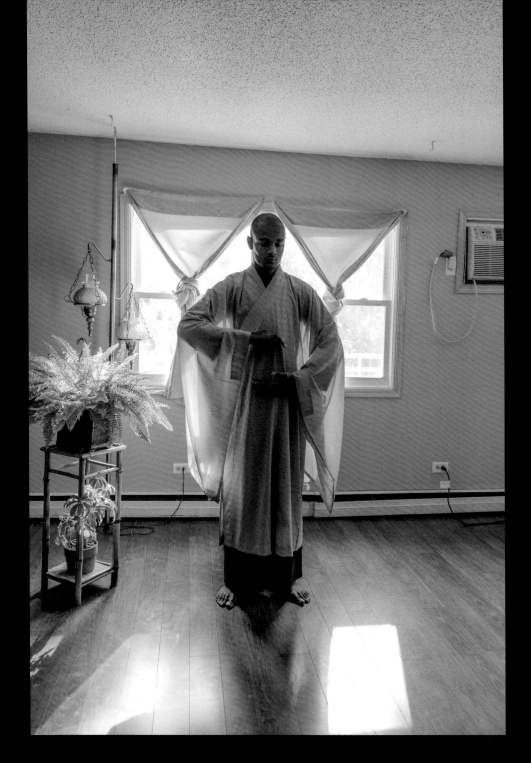

WHEN JARRELLE BARTON was sixteen, he performed for a Chinese New Year celebration at the Mall of America, playing a traditional Chinese stringed in- strument. Afterward a Chinese woman approached him and said, "I see the Buddha in you." At the time, he didn't know what she meant.

Perfect being imperfect

I met Jarrelle at the Mall of America's Chinese New Year celebration in 2017, when he was twenty-four. He has performed there free, in a shopping corridor, every year since his first appearance, at age sixteen. Amid the pomp of red lanterns and dragon dancers, I saw a young black man playing a familiar-sounding Chinese stringed instrument, which I couldn't name. The looks on the mostly Chinese faces in the audience seemed to range from appreciation to bemusement. But when a few approached him after the song to query him in English and he replied in Mandarin, their expressions turned to something approaching veneration or glee.

Several weeks later, Jarrelle agreed to be photographed at his home. He lives with his grandmother in a modest row house apartment in Prior Lake. It is infused with incense and embellished with four altars; a four-foot ceramic Buddha from Bachman's garden center and his five-foot instrument dominate the tiny living room. It took a while for me to understand just how much of an inner sanctum it was.

Jarrelle grew up in Cleveland, where he suffered trauma as a child and was diagnosed with PTSD at age thirteen. Depressed, he went to the public library every week to check out music CDs. One day he brought home one with Chinese music, and for the first time he heard the guzheng, a Chinese zither with a 2,500-year history. The expressive bending of the notes from flat to sharp spoke to him like a human voice and gave him chills. The sounds were "perfect being imperfect." He felt a deep connection that he had never felt before or since.

He promptly took a wooden tea tray and tied guitar strings to it to make his own guzheng. His grandmother, seeing his commitment to learning this instrument, broke down and bought one for $500. All the instructional videos, however, were in Chinese. Undaunted, Jarrelle taught himself Chinese, wallpapering every surface of their apartment with Chinese characters on flash cards he made.

After a year of teaching himself to play the instrument as well as read and speak Chinese, he realized he needed a real master. He found a teacher in the Twin Cities area and called to ask if the Chinese master would take him on as a student. He was fourteen. The teacher said yes, and so Jarrelle and his grandmother moved to Prior Lake, where they still live. After studying the guzheng with the teacher a couple of years and improving his Chinese, Jarrelle started to get sporadic performance gigs. But when I met him he said that he isolates himself in his apartment, sometimes going a couple of months without speaking with anyone.

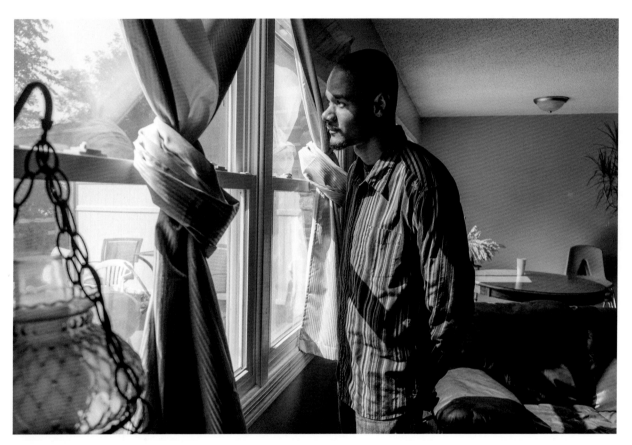

Jarrelle, Prior Lake, Minnesota

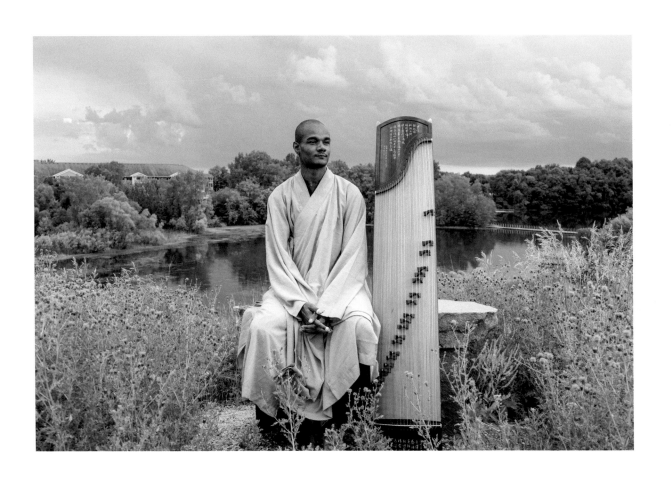

Music has one heart

Once, after a performance, a Chinese man came up to Jarrelle and told him that he shouldn't play this instrument because he is not Chinese. "You are black," the man said and gave him a book on drumming. Those comments "stabbed me in the heart," he said, and sent him into a deep depression for a month. "I felt distant from myself, as if I were ignoring my own heritage, my own history. Maybe I should give up because I'm not Chinese." But after deep introspection he realized that "music has one heart, one body, and one soul. It has no borders. It's all human culture."

In the past year (he is now twenty-five), with some assistance on my part and others', Jarrelle has been getting increasing offers to perform at schools, places of worship, colleges, and other venues. One music professor proclaimed him a "virtuoso and a genius." He has been active on WeChat, a major social media outlet in China, where one guzheng player said, "You are very spiritual, with the soul of zheng, you foreigner who lives in the soul of the Chinese people!"

Jarrelle: "When I first heard the guzheng, it was instant love! The sound instantly moved me and brought about emotions deep within my soul that stirred the spirit of music in my heart. Today, after twelve years of extreme and relentless practice, long hours of study, and bloody, calloused fingers, I see the reason I live, and it's to create and share music.

"Growing up in Ohio, I experienced bitter poverty, family violence, and violence outside of the home. At about age five, I witnessed the murder of a local man in front of church one Sunday. The screams echoed outside the church for years. I never had a stable home from childhood, and food was always low or sometimes none. I remember going days with only bread and honey.

"Milk was a rare treat. As the years passed, hardship kept growing, and one thing I had to learn was endurance! I had to endure the most extreme situations, and all of that fell in on my young life.

"At thirteen I found the greatest blessing, and that was guzheng. The guzheng has saved me from falling into a dark void, and its heavenly sound raised me higher! The long hours of daily practice began to make my endurance known to me, and after achieving the highest level in zheng music, learning from world-renowned Master Li Jiaxiang, I began to see that I have survived. I no longer question my purpose.

"My goal is to help many people find that peace and endurance they know is there by using music and practice. Practice is the best meditation anyone could have; it's a method of active meditation and deep internal healing, and by finishing a piece of music we learn that literally anything is possible, no matter how cold and bitter the outside world may seem. Music is both here and within."

For Jarrelle, the idea of identity is perhaps something to transcend. The perception of what is *appropriation* and what is *appropriate* is continually imposed upon him—a black man constantly reminded by society of his black-ness, who chose to play this traditional Chinese instrument, often in front of Chinese audiences. In our discussions, he once paraphrased Martin Luther King Jr.: "We should not be defined by the color of our skin but by the content of our character."

A few years ago, while meditating, he had a peaceful vision of himself in China amidst the mountains. His dream is to someday make that vision a reality.

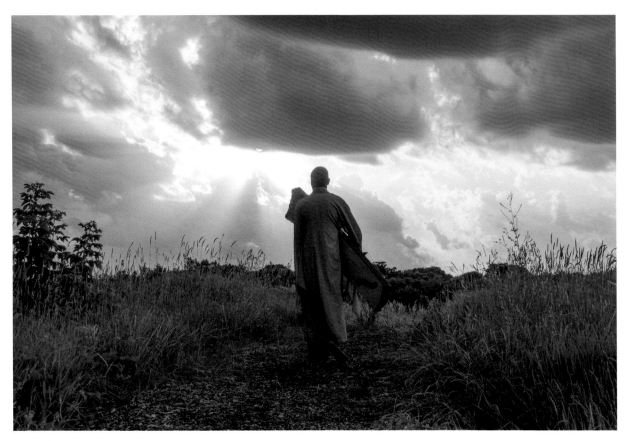

Prior Lake, Minnesota

ACKNOWLEDGMENTS

THE CONCEPT for this project originated in part as a result of a multiyear cultural exchange produced by Arts Midwest with funding support from the US Embassy–Beijing. Thank you to David Fraher, president and CEO, Stephen Manuszak, program director, and all the staff at Arts Midwest, who gave me the opportunity of a lifetime, bringing my photos and me to China, giving me the impetus to do this project. And thank you to the US Embassy–Beijing and US Consulate–Guangzhou, to their staff, Joanne Leese, Pan Haiyan, Justin Walls, Erika Kuenne, XT Song, Raymond Li (an excellent photographer who took several of the photos of me in China), Janice Englehart, and many others for all your guidance and participation in this bilateral effort.

This project is related to and draws from many of my other photographic projects, and I am grateful for the support I have received for all of these from many organizations over the years. I was recipient of an Artist Initiative grant from the Minnesota State Arts Board in 2013.

Thanks to Gayle Isa, executive director of Asian Arts Initiative, and her staff. Part of this project was created during an artist residency at Asian Arts Initiative in Philadelphia and exhibited there, made possible through support from the Visual Artists Network and National Performance Network. Major contributors are the Andy Warhol Foundation for the Visual Arts, the Joan Mitchell Foundation, the Ford Foundation, and the Pollock-Krasner Foundation.

Thanks to Karen Mueller, managing director, and all the staff at the History Theatre. This project was supported in part through a commission by the History Theatre in conjunction with the play *The Paper Dreams of Harry Chin*, written by Jessica Huang and directed by Mei Ann Teo.

Thanks to Donna Sack, vice president of community engagement and audience, and Lance Tawzer, director of innovation and experience at the Naperville Heritage Society–Naperville Settlement. Funded in part by a grant from the National Endowment for the Arts, I photographed the Asian-American community in Naperville for an exhibition at Naper Gallery: *ME = WE: An Asian Community Portrait by Wing Young Huie.*

THANK YOU to Pamela McClanahan, my former editor at the Minnesota Historical Society Press, for first believing in this project, and to my editor Ann Regan and all the staff for expertly helping me in so many ways to complete it. To Bridget Mendel and Mary Brenner for transcribing my audio interviews, to Xiaolu Wang and Viola Liu for translating text, and to Galen Fletcher for photo editing. To Mike Hoyt, fellow artist at my residency for Asian Arts Initiative, who gave me support in many ways, including taking the photograph of me as a member of the Philadelphia Suns. To Stephanie Rogers, also for photo editing, and for all your artistic guidance and support. Special thanks to Steven Zhang Han, an interpreter, translator, and guide who became a co-photographer, co-collaborator, and friend. Thank you to the hundreds of people in this book who made this large-scale collaborative possible.

I dedicate this book to all my Huie relatives and their families, here and in China and elsewhere, past and present, and most of all, to Mom and Dad.

Chinese-ness was designed and set in type by Percolator Graphic Design, St. Paul. Primary typefaces are Portada by TypeTogether, and Cholla Slab and Vista Slab by Emigre. Printed by Friesens, Canada.